DRINKING LIKE LADIES

75 MODERN COCKTAILS FROM THE WORLD'S LEADING FEMALE BARTENDERS

INCLUDES TOASTS TO EXTRAORDINARY WOMEN IN HISTORY

MISTY KALKOFEN AND **KIRSTEN AMANN**

Inspiring | Educating | Creating | Entertaining

Brimming with creative inspiration, how-to projects, and useful information to enrich your everyday life, Quarto Knows is a favorite destination for those pursuing their interests and passions. Visit our site and dig deeper with our books into your area of interest: Quarto Creates, Quarto Cooks, Quarto Homes, Quarto Lives, Quarto Drives, Quarto Explores, Quarto Gifts, or Quarto Kids.

First Published in 2018 by Quarry Books, an imprint of The Quarto Group, 100 Cummings Center, Suite 265-D, Beverly, MA 01915, USA.
T (978) 282-9590 F (978) 283-2742 QuartoKnows.com

Quarry Books titles are also available at discount for retail, wholesale, promotional, and bulk purchase. For details, contact the Special Sales Manager by email at specialsales@quarto.com or by mail at The Quarto Group, Attn: Special Sales Manager, 401 Second Avenue North, Suite 310, Minneapolis, MN 55401, USA.

10 9 8 7 6 5 4 3

ISBN: 978-1-63159-418-2

Digital edition published in 2018.

Library of Congress Cataloging-in-Publication Data available

Design: Tanya Naylor
Cover Illustration: Bijou Karman
Page Layout: Tanya Naylor
Photography: Adam DeTour Photography
Illustration: Bijou Karman

Printed in China

· DEDICATION ·

This little tome has been a dream of ours for more than a decade, and like so many of the women in this book, it's one we were told, time and again, wasn't worth pursuing. If we've learned one thing in all our research, it's that history rewards tenacity and persistence, and we can't think of a better reason to raise a glass. This book is also dedicated to Hazel Mae Kalkofen and Susan Catherine Amann, our moms, who have been our most enthusiastic supporters and our most gallant heroes since we were little defiant ones. We love you, mom.

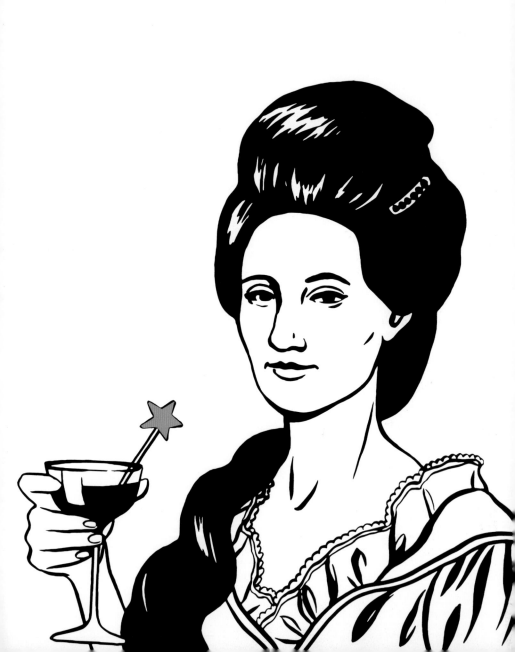

CONTENTS

Back in 2007, before fresh juice programs were *de rigueur* and even the local pub had a classic cocktail on the drink menu, Misty happened upon the website for an intriguing women's club based in Pittsburgh. It was called LUPEC, Ladies United for the Preservation of Endangered Cocktails. The classic cocktail revival was just taking root in our hometown of Boston, and it wasn't a challenge to identify fellow boozy broads who were intrigued by the LUPEC goal: dismantling the patriarchy, one drink at a time. We gathered for drinks at Misty's place, and before long we had formed the city's first and only female-oriented cocktail society.

At first, we met once a month in members' homes, where we experimented with recipes culled from the pages of vintage cocktail books, and we raised a glass to unsung women in history as we sipped. We started a blog, began writing a cocktail column in the local alt-weekly, and schemed up larger-scale events to raise money for local women's charities. Our first incorporated a month-long signature cocktail program at local bars and a 100-person Jazz Age–themed cocktail party on a riverboat in Boston Harbor. We raised $15,000, which we proudly donated to Jane Doe, Inc., the Massachusetts Coalition Against Sexual Assault and Domestic Violence.

We also started this book back then, believing cocktails and women's history to be a natural fit. Back in 2007 (and 2012 and 2015), we were very wrong; time marched on, many of the male colleagues we came up with published books, and despite the rejections, our hopes burned eternally for this project.

Three months after the 2016 election, we were quite surprised to receive an email through an old email address from our publisher: timing is everything. As many of the progressive policies we take for granted are rescinded and social norms turn retrograde, the time has never felt better to roll up our sleeves and get focused on our mission: dismantling the patriarchy, one drink at a time.

In an effort to expand our membership and evolve beyond the charter of the original LUPEC, we became the Toast Club in 2017. We take our name from a women's networking society founded in Boston, circa 1895, that the *Los Angeles Times* described as "a strong body of those women who can achieve anything when once braced by a handsome luncheon." We know little about these forebroads, beyond that they convened regularly to fortify with green swizzles and practice public speaking on relevant issues of the day, such as "The New Woman" and "The Future of the Husband."

Today the Toast Club continues the tradition. We preserve our own personal *joie de vivre* by guaranteeing members and guests good parties with green swizzles while striving to enhance and improve the lives of Boston-area women through fundraising events for women's charities. We partner with bars and liquor purveyors to offer coed classic cocktail parties and special events dedicated to drinking for a cause. We preserve drinks from a bygone era as we educate ourselves about the important, nearly forgotten forebroads who sipped them. We invite you to join us—in fact, by cracking open a copy of this book, you've already joined the party!

Girly Drink. What's the first thing that comes to mind when you hear that term? Something pink, like a cosmopolitan? Something tempered with flavoring, like honey whiskey? Something sweet and dessert-y like a chocolate martini? Or perhaps simply a drink with a name so absurd, no "man's man" would feel comfortable ordering it at the bar: _Raspberry Flirtini_, anyone? For whatever reason, our culture has come to equate sticky-sweet, silly-named Technicolor concoctions with female imbibing. You know, _Girly Drinks_.

Do you ever wonder what makes _these drinks_ right for women? A trip to your local liquor store reveals what liquor marketers think you should drink: "whiskey" that tastes like cinnamon **or** some "skinny-ized" variation of an otherwise classic drink. But is that really what you want?

You scour the farmer's market for the most perfectly ripe heirloom tomatoes. You're not afraid to try a chef's specialties, even when it's weird stuff like trotters or head cheese. You choose fresh-from-the-farm foods over processed products. So why on earth would you demand anything less from your cocktails?

Cocktails haven't always looked and tasted like processed confections. Pre-Prohibition, a time considered the Golden Age of cocktails, bartenders used fresh juices, syrups, and liqueurs to both soften and enhance the natural flavors of a base spirit to develop delightful drinks. As time marched on, the practice was squelched by some key historical events: Prohibition, two World Wars, the industrialization of our food systems, the rise of preservative-rich substitutes in lieu of fresh ingredients, and the trend toward drier drinks that followed. Flavorful spirits such as whiskey and gin gave way to neutral ones such as vodka, and for decades it seemed these good old pre-Prohibition classics didn't stand a chance.

Fortunately for modern drinkers, a generation of mixologists dusted off those nearly forgotten recipes, brushed up on the old techniques, and developed new recipes using antique templates. Renewed interest in the classics resurrected long-forgotten cordials and entire spirit categories. Fresh juice behind the bar has moved from niche specialty to _de rigueur_.

So, what does it mean to drink like a lady? To us, it's enjoying a well-balanced cocktail, passing on drinks that cover up the flavors of alcohol, learning about strong cocktails from strong-minded women, and never being pigeonholed into a "skinny girl" cocktail. _Drinking Like Ladies_ provides a collection of delicious recipes for every occasion—and more on some cool women who came before us to toast.

There is no shortage of unsung women to raise a glass to, and one of our biggest challenges has been narrowing our selection to just seventy-five remarkable women from history and today who inspire us. In these pages, you'll find seventy-five bespoke cocktails created by modern female bartenders. These are original drinks that toast the inspirational woman with whom they are paired. We put out the call for strong women to contribute, and we were overwhelmed by the responses, with friends and strangers connecting us to working bartenders all over the world, many of them up-and-coming. The cocktails they developed are creative, thoughtful, and inspiring. This book is not just a nod to women of the past, but a snapshot of the present and a glance toward mixology future: a cocktail time capsule.

We designed this book to help you rethink your drinks, and to shed some light on what we think "drinking like a lady" is all about. Our goal is to inspire a new generation of drinkers to put down that chocolate martini and pick up a pink lady—and help us give new meaning to the term "girly drink."

ESSENTIAL SPIRITS

In a perfect world, all the liquor you'd need to make the cocktails of your dreams would appear in your liquor cabinet with a snap of your fingers. In reality, you'll have to stock up. For a basic setup, here are our guidelines. You'll want medium- to top-shelf versions of the following:

Gin: There is a range of gins to explore, from London Dry to Old Tom to the malty genever. For the purposes of stocking your home bar with basics, go with London Dry.

Whisky/Whiskey: For the basics, grab a bottle each of rye, bourbon, Irish whiskey, and blended Scotch.

Brandy: Cognac and Armagnac are kings, but look for a wallet-friendly option, as you'll be mixing with the stuff.

Rum: Grab a bottle of unaged rum and a bottle of aged rum, and learn the rest on a per-cocktail basis.

Mezcal: Look for the wallet-friendly, 100 percent espadin variety for a start. By all means, avoid anything with the worm.

Tequila: Look for an unaged one for your starter bar, and make sure to choose a product made with 100 percent blue Weber agave.

Vermouth: Grab some dry vermouth (a.k.a. French) and sweet vermouth (a.k.a. Italian). Remember to treat it more like wine than spirit: Refrigerate it after opening, and drink swiftly to avoid oxidization.

Vodka: Vodka is flavorless and odorless, and if it's a good distillate, it doesn't matter if it was distilled two times or sixteen times. Don't overthink it.

ESSENTIAL MIXERS

JUICES

Citrus: Lemons and limes are a weekly purchase for us, and if you like orange or grapefruit juice, using the fresh stuff in cocktails will knock your socks off. Keep anything you plan to use relatively soon at room temperature, because it will be far easier to juice and will yield more liquid.

Pineapple juice: This is harder to just have on hand fresh. We've been known to keep small cans of Dole in the fridge for emergency piña coladas.

SYRUPS

Simple syrup: Essentially just sugar dissolved in water. The easiest recipe: combine one part sugar and one part warm water in a mason jar and shake to dissolve. Store in a glass bottle in the refrigerator for up to a month.

Grenadine syrup: Step away from the store-bought, brightly-hued kind because grenadine is easy to make at home. Combine equal parts unsweetened pomegranate juice and sugar in a saucepan, bring to a simmer, and stir to dissolve. Reduce the heat and simmer for 7 minutes, or until the concoction is thick enough to coat a spoon. Add an ounce (30 ml) gin or vodka to preserve, and an optional dash of orange blossom water.

Honey syrup: Combine equal parts honey and hot water and stir to dissolve.

Rich simple syrup is a sweeter version of simple syrup, using a 2:1 ratio of sugar to water. It's made in the same way simple syrup is.

Demerara simple syrup is made with unrefined demerara sugar, which has a pale amber color and toffee flavor.

BITTERS

Aromatic bitters: The most popular brand among these is Angostura (an essential ingredient in the Manhattan), which is made in Trinidad from a proprietary blend of herbs, roots, and spices.

Orange bitters: Made from the peels of bitter oranges and other herbs, roots, and spices, these appear in many classics, including early recipes for the storied martini.

Peychaud's bitters: Created by Antoine Amédée Peychaud, a famous Creole pharmacist, these bitters have a bright pink hue and an anise-y, cinnamon-y flavor.

ESSENTIAL MIXOLOGY

You don't have to be a ballerina to shake your groove thing, and you don't need to be able to double shake to mix up a delicious drink. Take your time and practice your skills. Here are some tips on basic cocktail techniques; more detailed videos and demonstrations are on the Toast Club website.

Shaking: Use plenty of ice! Dilution is key to your drink's quality, so shake less like you're rocking a baby to sleep and more like you're waking up a petulant teenager.

Dry shaking: Combine all your ingredients *without* ice in a cocktail shaker and shake vigorously for 10 seconds. Add ice and shake like your life depends on it to achieve a gorgeous, Instagram-worthy frothy top.

Stirring: This technique takes a little practice. The goal is to gently dilute with ice for a silky, smooth result. Think politely assertive rather than aggressive with your stir; too much activity and you might as well have just shaken it in the first place like that dumb James Bond.

Muddling: Use the mojito and the caipirinha as your rules of thumb. For drinks containing delicate herbs, such as a mint mojito, just give a little press with some of the liquid that's called for in your recipe, to express the oils but leave the bitter stem intact. For the caipirinha, which features lime wedges, put a little muscle into your muddle. Know your own strength, lest you break your mixing glass and waste your perfectly delicious cocktail.

Shake cocktails made with citrus, dairy, and/or eggs. Stir cocktails made with spirits and liqueurs. James Bond had it all wrong. Let's hope for a female 007 to correct this egregious error in our lifetime.

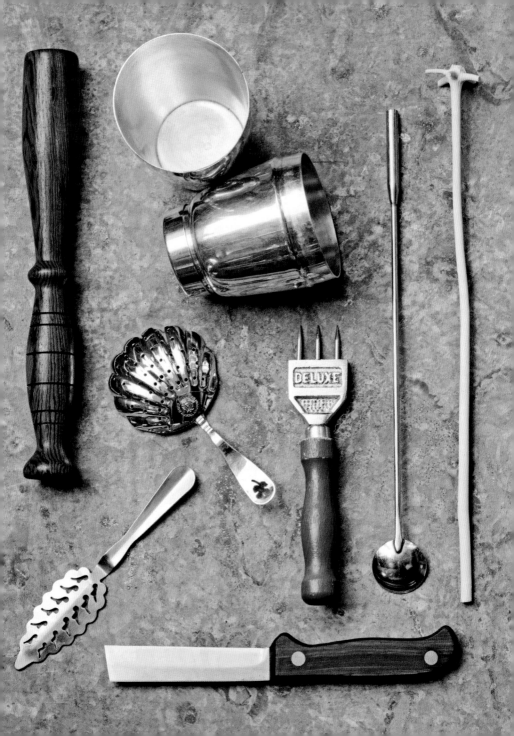

ESSENTIAL TOOLS

We include some of the best practices of the world's greatest bartenders—and the tools they swear by—in these pages. However, if made to choose between not having a cocktail and mixing a cocktail with whatever is on hand, we'll choose the butter knife in place of the barspoon every time.

Barspoon: A long-handled, shallow spoon with which to stir cocktails. It takes some skill to wield one like an expert, but after some practice you'll wonder how you lived without it. Should you be making martinis by the campfire, a knife or chopstick can suffice.

Boston shaker: This is a two-piece shaker that was born in the mid-nineteenth century, and it is the most important thing you can buy for your bar. It resembles your run-of-the-mill pint glass (commonly 16 ounces, about 475 ml) and a shaker tin (commonly 28 ounces, about 830 ml), which fits snugly on top, sealing its contents as you toss your drink back and forth inside it with ice. Believe in the seal and in physics; you won't spill!

Hawthorne strainer: A perforated strainer characterized by a semi-circular spring that fits snugly into the top of a shaker tin. Use it for shaken drinks.

Julep strainer: A perforated strainer with slightly larger holes than its cousin, the Hawthorne, and no spring. Use it for stirred drinks.

Mixing glass: This differs from ye olde pint glass in the sense that it is made with tempered glass. Fancier versions exist, but any glass vessel larger than the drink you are stirring can be your mixing glass.

Jigger/measure: A jigger has two cones of different sizes (make sure you check before you mix) affixed at the middle. Also popular are tiny angled measuring cups from Oxo.

Muddler: A long, thick, pestle-like tool used to press ingredients in the bottom of a cocktail glass.

Citrus squeezer: We are huge fans of the citrus squeezers with two handles that can be squeezed right over your mixing glass.

Y-peeler: For liberating swaths of citrus skin to gently express over your cocktail.

Lewis bag: A sturdy canvas bag in which to place your ice before whacking the heck out of it with a mallet.

Fine grater or zester: A sharp little one from Microplane will make you smile.

ESSENTIAL GARNISHES

Citrus peel or twist: Liberate the peel without slicing into the pith or fruit. Express the oil over your cocktail and run the garnish gently around the rim of the drink before serving. For recipes that use citrus oil as garnish, simply discard the peel after expressing the oil.

Maraschino cherry: Look for real Maraschino cherries, which hail from Italy and are a deep red hue preserved in sugar. Luxardo cherries are the most famous. Or experiment with making your own brandied cherries at home.

Fresh herbs, such as mint: Look for the freshest, greenest herbs and give them a gentle slap before placing them in your cocktail to gently break some of the cell structure, thus releasing those sought-after oils that make your cocktail so delicious.

Salt or sugar rim: Using a gentle, careful hand when preparing a rimmed cocktail is key, as applying too much to the glass can cause it to fall into the drink, turning your carefully prepared margarita into a salty soup. See the Toast Club website for detailed instruction.

ESSENTIAL GLASSWARE

We adore scouring flea markets, estate sales, and eBay for vintage glassware. After your second or third cocktail, however, you may wish to step away from the eBay, lest you wake up to four lots of vintage coupes and a much lighter wallet. Not that we've done that . . .

In addition to julep cups and a punch bowl with glasses, below are the basics you will want to have on hand. They can be purchased cocktail by cocktail as your budget allows.

Coupe glass

Nick & Nora glass

Old Fashioned/ rocks glass

Other glasses used in this book:

Tiki glass

Highball/ collins glass

Martini glass

Flute

Double Old Fashioned/ rocks glass

Wine glass

01

CHAPTER

GIN

I n the decade since the inaugural meeting of LUPEC Boston, Ladies United for the Preservation of Endangered Cocktails, gin has arrived. It's gone from the drink of our granddads that our young, hip bar guests refused to touch to one of the most popular sips ordered by savvy cocktailians. This excites us for many reasons. First, it is a spirit that served as vodka's less approachable sibling for too long; second, there is a vast universe of classic cocktails that employ gin as the base; and finally, gin is enjoying a renaissance, with new exciting styles released each year. What follows are modern creations that employ gin artfully enough to bring a tear to our eyes.

Cin cin to gin!

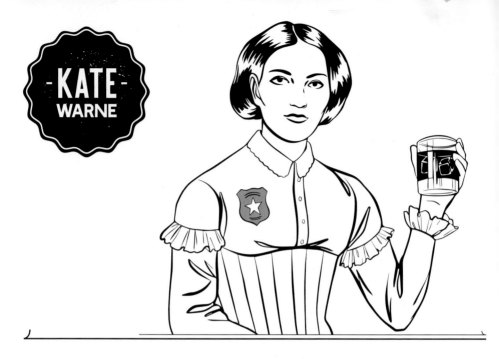

(1833—1868), Detective

—

Whether you are of the generation of *Charlie's Angels, Hart to Hart,* or *21 Jump Street,* you can likely agree that seeing a smart, poised woman going undercover to deter a crime is an exciting yet relatively rare television occurrence. All the more reason to turn our attention to the first female private detective, Kate Warne.

In 1856, a young woman walked into the Pinkerton National Detective Agency. Allan Pinkerton assumed she was seeking clerical work, but to his surprise, Warne announced she was responding to his advertisement in search of detectives. Persuaded by her argument that female detectives could be "most useful in worming out secrets in many places which would be impossible for male detectives," Pinkerton hired her.

In 1861, Pinkerton's was hired by the president of the Philadelphia, Wilmington & Baltimore Railroad. While investigating concerns about secessionists damaging the railroad, Warne uncovered a possible plot to assassinate President-elect Abraham Lincoln. Warne used several aliases, a cockade or secession ribbon, and a thick Southern accent to infiltrate high society Baltimore and uncover the intimate details of the upcoming assassination attempt. A complex plan was developed to bring Lincoln from Philadelphia to Washington D.C. safely by having him pass through Baltimore in the sleeper car of a public train disguised as Warne's sick brother. Aided by the cover of night and a team of horses to pull the train through Baltimore, abiding by the city's nightly noise ordinances, Warne escorted her precious cargo to his destination.

Warne continued to work with Pinkerton through the Civil War, before passing at the young age of 35 due to pneumonia.

Gincidents

The roots of gin are planted in the field of medicine. Seventeenth-century Dutch alchemists attempted to harness the healthful properties of juniper berries in tinctures to treat everything from kidney maladies to plague prevention. The malty Dutch genever wooed the British soldiers fighting in the Thirty Year's War, who happily embraced this "Dutch Courage." This new love returned to England with the soldiers, becoming a modified, cheaper, non-malted version better suited for production in urban areas. In the U.S., gin's popularity skyrocketed during the dry days of Prohibition, when bathtub versions were easily made with bootlegged neutral spirit and a vial of juniper oil from the *Sears, Roebuck & Co. Catalogue*.

WARNE-ING SHOT

YIELD: 1 cocktail

Glassware: 10-ounce (285 ml) etched rocks glass

Garnish: lemon twist

INGREDIENTS

» 2 ounces (60 ml) gin

» ¼ ounce (7 ml) Pink Peppercorn Syrup (see below)

» 2 dashes Bitter Truth celery bitters

» 1 dash grapefruit bitters

Pink Peppercorn Syrup

YIELD: about 4 cups (1 L)

» 3 ounces (84 g) pink peppercorns

» 34 ounces (1 L) water

» 4 cups (800 g) sugar

» 2 tablespoons Peychaud's bitters, plus more for coloring, if desired

By Kalliopi C. Nikou
Mercy Lounge, Nashville, TN

Kalliopi selected pink peppercorns when creating this cocktail as a nod to Kate's tenure at the Pinkerton Agency: "Pink with a punch was the goal, as a reminder that drinking like a lady does not restrict us to pink and fruity."

DIRECTIONS:

Pour all ingredients into a rocks glass, add the biggest piece of ice you can find, and give it a stir (your finger will do) to dilute.

Syrup

Preheat oven to 350°F (175°C, gas mark 4). Spread pink peppercorns on a cookie sheet and bake for 5 minutes. In the meantime, bring water to a boil. Once boiling, add peppercorns directly from oven to water. Return water to a boil, then add sugar and bitters. Strain off peppercorns while still hot. Add more bitters if more of a pink color is desired.

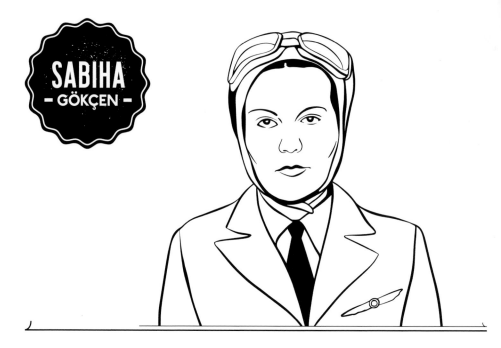

SABIHA
- GÖKÇEN -

(1913—2001), Aviator

—

For most, it takes years to understand that to get what you want or need, you frequently have to ask for it. Sabiha Gökçen recognized this at a young age, setting her up for adventure and success. In 1925, in her hometown of Bursa, Turkey, Sabiha's path crossed with the newly elected Turkish President Mustafa Kemal Atatürk. The precocious twelve-year-old approached Atatürk to ask for assistance in continuing her education in boarding school. This fearless move resulted in Sabiha becoming one of Atatürk's several adopted children. Like Cher, at this time she was simply known by her first name, Sabiha. However, with Atatürk's 1934 Surname Law, which required all citizens to take a family name, her last name became Gökçen, a prescient designation that means "of the sky."

Atatürk, a proponent of modernization, aviation in particular, was the guest of honor at the opening of the Türkkuşşu Flight School in May of 1935.

He and Sabiha witnessed a daring air show that included sky divers and parachutists, after which Sabiha announced her desire to join them. She was enrolled that day as the school's first female student.

Sabiha's interests quickly turned from aerial acrobatics to flying. After acquiring her pilot's license, she continued her aeronautical training in Russia, the only woman in a group of seven. In 1936, Sabiha made her first solo flight, an event recognized across the country as an example of the new freedoms accessible to all Turkish women.

In 1937, Sabiha continued her training on military aircraft, taking part in military exercises in the Aegean Sea and completing a solo combat mission, resulting in her recognition as the first female combat pilot.

To this day, world travelers honor Sabiha's barrier-breaking accomplishments daily when checking into Sabiha Gökçen International Airport, one of the two major airports serving Istanbul.

LINE OF FLIGHT

YIELD: 1 cocktail

Glassware: coupe glass

Garnish: Ground or crushed pink peppercorn

INGREDIENTS

» 1½ ounces (45 ml) gin, preferably London dry

» 1 ounce (30 ml) Lustau Los Arcos Amontillado sherry

» ¾ ounce (22 ml) Pink Peppercorn and Black Tea Simple Syrup (see below)

» ½ ounce (15 ml) fresh lime juice

» ½ ounce (15 ml) egg whites

» 1 teaspoon (5 ml) rich simple syrup

Pink Peppercorn and Black Tea Simple Syrup

YIELD: approximately 300 ml

» 1 tablespoon (7 g) ground pink peppercorns

» 2 black tea bags

» 1 cup (240 ml) hot (almost boiling) water

» 1 cup (200 g) granulated sugar

By Sylvi Roy
Portland Hunt + Alpine Club, Portland, ME

Creator Sylvi Roy was terrified of heights, so she took up skydiving. Line of Flight is a skydiving term denoting the theoretical line that a skydiver is dropped into over the ground where they will be landing, a line that is never definite or set—a nod to Sabiha's, and Sylvi's own, adventurous spirit.

DIRECTIONS:

Place all ingredients in a shaker. Add plenty of ice. Shake well. Double strain back into shaker and dry shake for 30 seconds, or until any small ice chips have been incorporated. Pour into a coupe glass and sprinkle with or grate pink peppercorn.

Syrup

Steep ground peppercorns and tea bags in water for 4 minutes. Press tea bags. Fine strain into a new vessel and stir in sugar until incorporated. If sugar doesn't easily dissolve, place on a burner over low heat until sugar is melted. Let cool.

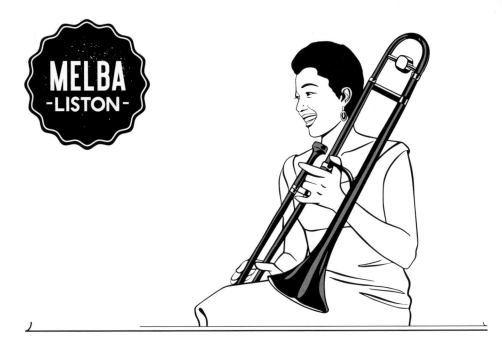

(1926—1999), Musician

—

At the age of seven, Melba Liston first saw the gleaming beauty of the slide trombone, creating a love that would last a lifetime.

Within a year, young Melba was playing her first solo on a local radio station in her hometown of Kansas City, Missouri; by sixteen, she had joined the union for professional musicians in her new home of Los Angeles, California.

Liston worked at the Lincoln Theater in Los Angeles, where she would branch into composing and arranging, skills for which she was acclaimed throughout her career. As a touring trombonist, Melba played with some of the best of the era, including Dizzie Gillespie, Count Basie, and Dexter Gordon, who composed his famous "Mischievous Lady" as a tribute to Liston.

The world of the touring musician comes with its share of hardships, and for an African-American woman the challenges were amplified. Rare was the case in the 40s and 50s that a touring gig was financially secure. Melba, however, was also facing racism and misogyny and suffering abuse, discrimination, and sexual assault, which resulted in her leaving the music industry for a time. Returning to Los Angeles, she worked with the Board of Education and supplemented her income with bit pieces in films.

In 1958, Liston recorded her only record as a bandleader, *Melba Liston & Her Bones*. Accompanied by some of the best of her male counterparts, Melba's skills stand out, yet the recording remains relatively obscure.

Liston continued to arrange and compose throughout her life. In 1987, she was awarded the Jazz Masters Fellowship of the National Endowment of the Arts, a testament to the impact she had during her career.

The horn has always saved me from sadness. If you take care of your music, the music will take care of you.

—MELBA LISTON

MISCHIEVOUS LADY

YIELD: 1 cocktail

Glassware: Nick & Nora glass

Garnish: lemon zest

INGREDIENTS

» 1½ ounces (45 ml) gin

» ½ (15 ml) ounce sloe gin

» ⅕ ounce (6 ml) maraschino

» barspoonful Punt e Mes

» dash lemon bitters

By Jemima McDonald

Earl's Juke Joint, Newtown, New South Wales, Australia

Jemima McDonald selected Mischievous Lady *as a tribute to Melba Liston herself: "The drink is sweet, tart, and herbal, but most importantly, boozy. A stiff, complex drink for a strong, multi-talented woman."*

DIRECTIONS:

Pour all ingredients into a mixing glass. Fill with ice and stir. Strain into a chilled Nick & Nora glass. Express the lemon zest over the top of the drink, and rest the garnish on the side of the glass.

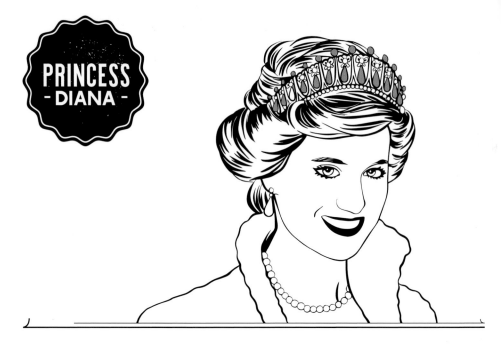

PRINCESS - DIANA -

(1961–1997), Princess/Activist
—

Lady Diana's wedding to Charles, Prince of Wales, was viewed by 750 million people worldwide, and it was the epitome of a fairytale affair. Their happiness together would be short-lived, marred by scandalous affairs, separation, a tabloid book confessing all her secrets, and divorce, all splashed across the pages of gossip magazines as the world watched.

As a young princess, Diana beguiled the public with her shy air, but she struggled with depression and bulimia behind the scenes during her difficult marriage. After her divorce, Diana blossomed. She wanted to be an ambassador and, undeterred by the fact that she had been stripped of the HRH portion of her royal title, she was passionately devoted to raising money and awareness for humanitarian causes. In 1997, seventy-nine of her royal gowns went up for auction at Christie's in New York to raise money for the Royal Marsden Hospital Cancer Fund and

the AIDS Crisis Trust. "Sequins save lives," was the promotional tagline; the event raised $3.26 million.

Diana was taught the power of touch from a nurse, who on one of her many hospital visits advised that, if you touch people's hands, they will feel your connection. She famously never wore gloves, and in 1987, at the height of the AIDS epidemic, clasped the hands of a patient at a clinic she had recently opened in London. At a time when many erroneously believed you could contract the disease through skin contact, Diana showed the world that, "HIV does not make people dangerous to know. You can shake their hands and give them a hug. Heaven knows they need it."

Cheers to Princess Diana! You will forever be the People's Princess.

> **I'm never frightened when I do good.**
>
> —PRINCESS DIANA

PARK HOUSE

YIELD: 1 cocktail

Glassware: coupe glass

Garnish: fresh gardenia

INGREDIENTS

» 2 ounces (60 ml) English Breakfast Tea-Infused Bombay Sapphire Gin (see below)

» 1 ounce (30 ml) Gardenia Flower Simple Syrup (see below)

» ¾ ounce (22 ml) lemon juice

» ¾ ounce (22 ml) egg whites

English Breakfast Tea–Infused Bombay Sapphire Gin

YIELD: 3 cups (750 ml)

» 4 English breakfast tea teabags

» 3 cups (750 ml) Bombay Sapphire Gin

Gardenia Flower Simple Syrup

YIELD: 2 cups (475 ml)

» 2 cups (475 ml) water

» 2 cups (400 g) sugar

» 1 ounce (28 g) organic dried gardenia flowers

By Stefanie Carr

Durk's Bar-B-Q, Providence, RI

Creator Stefanie Carr selected Bombay Sapphire Gin infused with English breakfast tea for this drink, inspired by its iconic blue bottle, and because "it's strong like Diana: she wore a stunning blue sapphire ring and had beautiful blue eyes. Blue is her color. And who could forget her blue eyeliner!" Gardenia flower syrup is a nod to the Lady Diana White Garden at Kensington Palace, a memorial garden in her honor that is a stunning display of gardenias and other white flowers.

DIRECTIONS:

Dry shake all ingredients in a cocktail shaker for 20 seconds. Add ice, shake vigorously, and strain into a glass. Garnish with gardenia.

Gin

Soak teabags in gin, tasting every 5 minutes until desired balance is achieved—no more than 15 minutes. Watch for astringency. The final result will have the color of a freshly brewed, properly steeped cup of tea.

Syrup

In a medium saucepan, bring water to a boil, then add sugar and stir until dissolved. Remove from heat and stir in dried gardenia flowers. Let sit for two hours or until desired taste is achieved. Strain flowers and store in glass bottle in fridge.

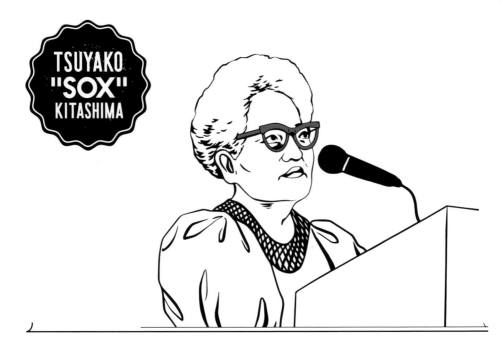

TSUYAKO "SOX" KITASHIMA

(1918—2006), Activist
—

On February 19, 1942, via executive order, President Franklin D. Roosevelt forced all Japanese-Americans to evacuate the West Coast. With a quick swipe of a pen, he upended the lives of 120,000 people, two-thirds of whom were American citizens, in one of the most flagrant violations of civil rights in U.S. history.

Born in California in 1918, Tsuyako Kitashima was nicknamed Sox by fellow students who couldn't pronounce her name. At twenty-three, she and her family were forced off their small strawberry farm and "relocated" to Tanforan Assembly Center, a temporary camp at a horse racetrack. "They were put in horse stalls, and there was hay on the floors and horse manure," recounts her son, Alan Kitashima. After several months, the family was moved to Topaz War Relocation Center in Utah. They were later split up, with several family members relocated to a Colorado camp. In 1945, Sox was released and returned to

California, where she married and worked at the San Francisco Veterans' Administration for thirty years.

Sox retired in 1981 to devote her full energy to seeking justice for the Japanese-Americans interned during the war. She became a spokesperson for the National Coalition for Redress and Reparations, championing the Civil Liberties Act of 1988. Granting reparations of $20,000 to all people interned during the war, the act was a formal apology from the American government. It only took forty-six years.

Sox volunteered and educated until she died, a vibrant member of the Nikkei community remembered as the Godmother of San Francisco's Japantown.

Shelf life of a shrub

Like pickled vegetables, you're very likely to use all of it before it spoils. "Theoretically speaking, you could make a shrub and leave it on your countertop for over a year or more and the shrub won't rot or spoil," says spirits journalist and author of *Shrubs* Michael Dietsch. "The worst that will happen to it is that the flavors degrade over time."

THE KITASHIMA

YIELD: 1 cocktail

Glassware: 8-ounce (240 ml) lowball glass

Garnish: lemon wheel and shiso leaf

INGREDIENTS

» 1½ ounces (45 ml) Plymouth Gin

» ½ ounce (15 ml) umeshu

» 1½ ounces (45 ml) Strawberry/ Shiso Shrub (see below)

» ½ ounce (15 ml) lemon juice

» soda water

Strawberry/Shiso Shrub

YIELD: 2 cups (475 ml)

» 2 cups (400 g) granulated sugar

» 2 cups (475 ml) water

» 2 cups (340 g) sliced strawberries

» 10 shiso leaves

» 1½ to 2 cups (355 to 475 ml) apple cider vinegar

By Kate Durgin
B&G Oysters, Boston, MA

This tart, juicy cocktail is a delicious combination of a classic pre-Prohibition shrub and the mint-like shiso leaf often found in Japanese cuisine. Creator Kate Durgin worked with strawberries as a nod to Sox's family farm, calling this the Kitashima to honor Sox and her family, who deserve an iconic drink.

DIRECTIONS:

Place gin, umeshu, shrub, and lemon juice in a shaker with ice. Shake. Strain into a glass. Top with soda water and stir gently. Garnish with lemon wheel and shiso leaf and serve.

Shrub

Place the sugar and water in a saucepan. Heat, stirring, until sugar dissolves. Add strawberries and simmer until fruit blends well into the syrup. Add shiso.

Let mixture cool. Strain, add vinegar to the syrup, bottle it all up, and store in the fridge.

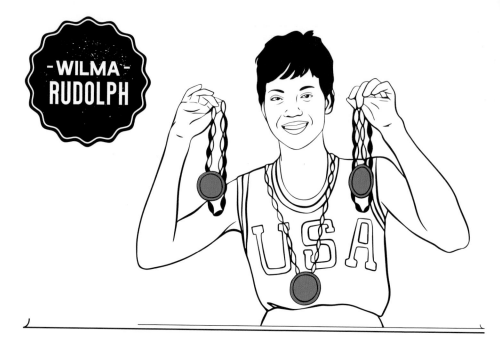

WILMA RUDOLPH

(1940—1994), Athlete
—

Wilma Rudolph was born premature, weighing just 4.5 pounds (2 kg). She fell ill often as a child, contracting chickenpox, scarlet fever, measles, mumps, pneumonia, and polio, resulting in infantile paralysis. "My doctors told me I would never walk again," remembers Rudolph. "My mother told me I would. I believed my mother." Rudolph wouldn't just walk: she would become the fastest woman in the world.

Rudolph wore a leg brace and went through extensive physical therapy until she was finally able to walk without the aid of medical devices at age twelve. By high school, she played basketball, setting a Tennessee state record by scoring 803 points in 25 games, and started running track and field as a gifted sprinter. Tennessee State Track and Field coach Ed Temple took notice when she was fourteen years old, and he trained her during summer breaks. In four years of high school track meets, she never lost a race.

At sixteen, Rudolph became the youngest member of the U.S. Track and Field Team, bringing home a bronze medal from the 1956 Melbourne Olympics. Four years later, she would be back for gold.

In the 1960 Rome Olympics, Rudolph was on fire, gliding past competitors to set two world records and earn three gold medals. The event was covered internationally for the first time, making Wilma world-famous. Upon returning home, she learned the ticker tape parade in her honor was going to be segregated and refused to attend, forcing change; the parade and banquet in her honor became the first integrated municipal events in her hometown of Clarksville, Tenessee.

Rudolph retired from athletics at twenty-two and became a teacher and track coach. She was inducted into the U.S. Olympic Hall of Fame and established the Wilma Rudolph Foundation to promote amateur athletics.

CATCH ME IF YOU CAN

YIELD: 1 cocktail

Glassware: Old Fashioned glass

Garnish: Tajín seasoning and lime wheel

INGREDIENTS

» 1 ounce (30 ml) No.3 Gin

» ¼ ounce (8 ml) Martini Rosso vermouth

» ¼ ounce (8 ml) Campari

» 1 ounce (30 ml) Bell Pepper, Strawberry, Ginger, and Chili Syrup (see below)

» 2 ounces (60 ml) fresh pomegranate juice

» ¼ ounce (8 ml) fresh lime juice

» 2 pinches ground black pepper

» ¼ ounce (8 ml) egg whites

Red Bell Pepper, Chili, Strawberry, and Ginger Syrup

YIELD: varies

» 1 large red bell pepper, chopped

» ⅔ cup (100 g) chopped strawberries

» 1½ tablespoons (7 g) fresh red chili pepper

» 1⅕ cups (280 ml) water

» 1½ cups (300 g) superfine sugar

By Rebecca Sturt

Pineapple Bar Consultancy, Dubai, United Arab Emirates

Creator Rebecca Sturt was inspired by Wilma winning three gold medals in Rome and her love of the three-ingredient Italian classic cocktail, the Negroni. She added fresh, healthy ingredients for athlete Wilma.

DIRECTIONS:

Place all ingredients in a shaker. Hard shake with large cubes of ice. Strain and shake again without ice for foam and texture. Strain into a glass over a large piece of ice. Garnish with Tajín seasoning and lime wheel and serve.

Syrup

Combine all ingredients in a saucepan and heat, stirring, until sugar dissolves. Simmer until thick. Allow to cool completely. Transfer to an airtight container and store in refrigerator.

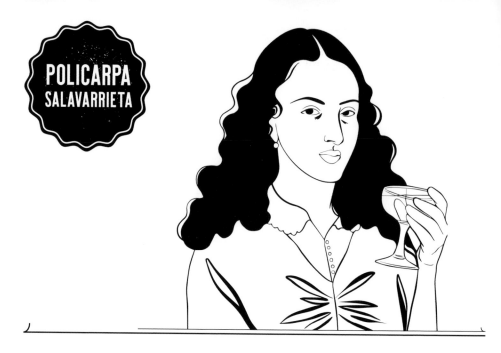

POLICARPA SALAVARRIETA

(1795–1817), Activist

—

W hen Napoleon invaded the Iberian peninsula, Spain's colonies in the New World seized the opportunity to advance their wars for independence. By 1814, with Napoleon out of his hair, the restored Spanish King Ferdinand VII was having none of that: He sent armies to quell the rebels in New Granada (present day Colombia), ushering in the Spanish Reconquista. Policarpa Salavarrieta, Colombia's heroine of independence, would become the most famous revolutionary to fight back.

Policarpa was born the fifth of nine children to an upper-class family in the Viceroyalty of New Granada. In 1802, she lost her mother, father, a brother, and a sister to smallpox, and she was sent to live with her godmother, where she learned to be a seamstress.

In 1817, Policarpa returned to Bogotà with her younger brother, both under aliases, carrying hidden letters to the leaders of the Revolution. She

took her place in the fight and in history, working as a seamstress in prominent royalists' homes and reporting intelligence back to rebel leaders. She was a skilled recruiter who could intuit which soldiers in the Royalist armies had hearts that weren't in the fight, then convince them to defect and join the patriots. Signed letters from Policarpa vouched for these new recruits.

These signed letters would be her demise after a patriot leader was caught with a long list of the names of her recruits. She was offered freedom if she confessed to her crimes, but she refused. Policarpa was marched to the firing squad, accompanied by two priests who recited prayers she was meant to repeat, famously screaming patriot rhetoric over their words. Young Jose Hilario Lopez looked on inspired and continued to share the story of her bravery after becoming the president of the liberated Republic of Colombia.

Cheers to Policarpa, who could never be silenced!

> **Although I am a woman and young, I have more than enough courage to suffer this death and a thousand more.**
>
> — POLICARPA SALAVARRIETA

YIELD: 1 cocktail

Glassware: coupe glass

Garnish: lemon twist

INGREDIENTS

- » 2 ounces (60 ml) gin
- » 1 ounce (30 ml) elderflower liqueur
- » 1 ounce (30 ml) Sauvignon blanc
- » ½ ounce (15 ml) simple syrup
- » ½ ounce (15 ml) lemon juice
- » 2 dashes Angostura bitters

By Diana Morell

Freelance Bar Consultant, Boston, MA

Creator Diana Morell is from Colombia. A seamstress, she attended a school named for Salavarrieta. "The scent of elderflower combined with the aromatic Angostura bitters provides layers of flavor, creating a complex, strong, ladylike drink that still retains its individual flavors through the finish, like Policarpa Salavarrieta, who retained her values and commitment to her cause without compromise!"

DIRECTIONS:

Fill shaker with ice. Add all ingredients. Shake vigorously. Strain into a coupe glass. Garnish with a lemon twist and serve.

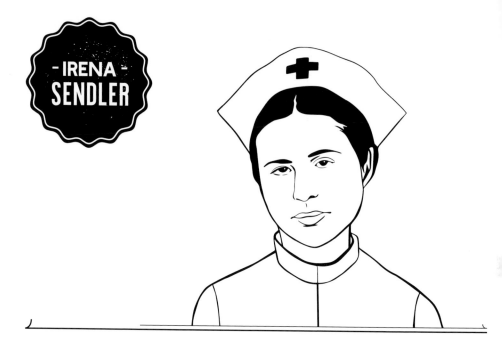

IRENA SENDLER

(1910—2008), Activist

—

Sometimes life's most challenging moments help us learn our most important lessons and discover a strength of character we didn't know we had. Irena Sendler's father died when she was seven years old. A physician, he contracted Typhus while treating Jewish patients whom other doctors would not treat. His final words to her were, "If you see someone drowning, you must jump in and try and save them, even if you don't know how to swim," instilling in Irena a respect for humanity that would guide her actions throughout her life.

Sendler attended Warsaw University, where she opposed the ghetto bench system that required segregated seating for Jewish students under threat of expulsion. Irena defaced her grade card in protest, an act that resulted in a three-year suspension.

When the Germans invaded Poland, Irena began assisting her Jewish neighbors by providing food, clothing, and water. In 1942, the creation of

the Warsaw Ghetto was a call to action for Sendler. She joined the resistance group Zegota, which had been formed in response to the deportation of Warsaw Jews to the Treblinka death camp. As the head of the Children's Department, Sendler would enter the ghetto daily using a pass from the Warsaw Epidemic Control Department. Aided by a network of accomplices, Sendler smuggled hundreds of children from the ghetto and placed them in orphanages in convents for safety. Sendler kept meticulous records of each child's whereabouts buried in hopes of reuniting families after the war.

In October of 1943 her subversive activities were discovered by the Gestapo. She was imprisoned, tortured, and sentenced to death; however, she was able to escape by bribing a guard. She spent the remainder of the war in hiding while clandestinely assisting Zegota. It is estimated that Sendler and her comrades in Zegota saved more than 2,500 children during World War II.

> **Every child saved with my help is the justification of my existence on this Earth, and not a title to glory.**
>
> — I R E N A S E N D L E R

HUNTER CHAIN

YIELD: 1 cocktail

Glassware: coupe glass

Garnish: lemon oils

INGREDIENTS

» 1½ ounces (45 ml) Tanqueray No. Ten

» ½ ounce (15 ml) fino sherry

» ¼ ounce (8 ml) verjus

» ¼ ounce (8 ml) Italicus

» 1 teaspoon (5 ml) Passion Berry Syrup (see below)

Passion Berry Syrup

YIELD: about 3 cups (700 ml)

» 20 passion berries

» 2 cups (450 g) granulated sugar

By Madeleine Rapp
The Dead Rabbit Grocery & Grog, New York, NY

"Would I be as brave as her in that situation?" mused drink creator Madeleine Rapp while developing this cocktail. "I would like to think so! I wanted to make a powerful yet bright and floral drink, something served up that Irena could enjoy and that would make her feel fabulous."

DIRECTIONS:

Pour all the ingredients into a mixing glass with ice and stir until cold. Pour into a coupe glass. Garnish with lemon oils and serve.

Syrup

Place passion berries, sugar, and 2 cups (475 ml) water in a pot. Heat over low heat for 1 hour. Remove from heat and cool to room temperature. Strain through cheesecloth and refrigerate.

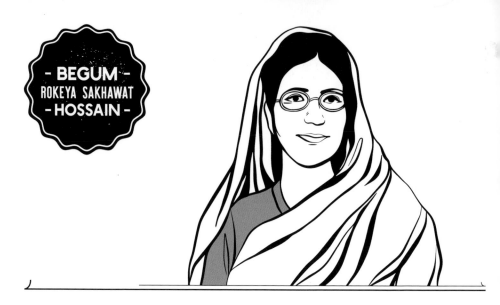

(1880—1932), Writer/Activist

—

Begum Rokeya Sakhawat Hossain's life is a study in contrasts, from her birth into an Orthodox Muslim family to her rise as one of the first Islamic feminists. Begum Rokeya was born into a traditional family in Pairabondh, Rangpur. Her father was a powerful landlord and, as was custom among the nobility, he insisted that the women in his family keep purdah, a system of social laws that secluded women from observation through modest dress and physical separation. Her father invested time and resources in educating her brothers, while Begum Rokeya and her sister were only allowed to study the Koran and were forbidden to learn languages beyond Arabic and Persian. Her older brother, however, believed in the importance of educating women and began teaching Begum Rokeya and her sister secretly.

At the age of eighteen, Begum Rokeya married Syed Sakhawat Hossain, a civil servant who believed that the ills of society could be remedied through the education of young women. He passed away eleven years later. She opened a school for girls in his memory and continued to fight for affordable and accessible education for women throughout her life.

Begum Royeka was a prolific writer who used humor, satire, and irony in her essays and novels to shine a light on the inequalities faced by women. She said, "We constitute one half of the society and if we are left behind, how can the society progress? If a person's one leg is tied, how far can he go?" She was also critical of the role that religion had played in subjugation, believing that women fulfilling their true potential was necessary in order to truly know and revere the divine.

Begum Rokeya proved herself a humanist through her writings, advocating that her readers should first identify themselves as Indians before considering ethnic- and religious-based nomenclatures.

The Toast Club believes this is a lesson we desperately need to remember. We raise our toast to Begum Rokeya Sakhawat Hossain and our commonalities!

LADYLAND FIZZ

YIELD: 1 cocktail

Glassware: collins glass

Garnish: 2 green cardamom pods

INGREDIENTS

» 2 ounces (60 ml) Apricot-infused Beefeater (see below)

» ¾ ounce (20 ml) lemon juice

» ¾ ounce (20 ml) Cardamom Syrup (see below)

» ¾ ounce (20 ml) heavy cream

» 2 dashes rosewater

» 1 egg white

» club soda

Apricot-infused Beefeater

YIELD: 1⅔ cups (400 ml)

» 1⅔ cups (400 ml) Beefeater Gin

» ⅔ cup (125 g) chopped dried apricots

Cardamom Syrup

YIELD: about 1 cup (240 ml)

» 45 green cardamom pods, crushed

» 1 cup (200 g) granulated sugar

By Ranjini Bose

Dear Irving, New York, NY

Drink creator Ranjini Bose shares a Bengali heritage with her inspirational lady. Featuring the flavors from the Bengali dessert rossogolla, Ladyland Fizz refers to the feminist utopia imagined in Hossain's <u>Sultana's Dream</u>, where women are in charge, war and crime have been eliminated, and great technological strides have been made: this is Ladyland.

DIRECTIONS:

Combine gin, lemon juice, cardamom syrup, heavy cream, rosewater, and egg white in a shaker. Shake ingredients together, first without ice. Add ice and shake vigorously. Strain into a collins glass without ice. Slowly top with soda, until a stiff peak forms. Garnish with a straw and cardamom pods and serve.

Apricot-infused Beefeater

Combine gin and apricot. Let sit 15 minutes. Strain.

Syrup

Bring 1 cup (240 ml) water to a boil in a saucepan. Stir in cardamom pods and sugar until sugar dissolves. Remove from heat and let sit for 15 minutes. Strain.

(1914—2000), Actress/Inventor

—

I n the hospitality industry, bartenders and servers frequently confront inaccurate assumptions made by our guests, the most common being that we are in this business because we lack knowledge or skills in other fields. We are guessing that Hollywood starlet and inventor Hedy Lamarr faced something similar.

Hedy Lamarr was born Hedwig Eva Maria Kiesler in Vienna, Austria. She began her film career at the age of seventeen and continued working in German and Czechoslovakian films until her Hollywood break when she was twenty-three. Hedwig left Austria and Hedy Lamarr arrived in Los Angeles, where she became a box-office sensation after only one film.

In 1942, at the height of her career, Lamarr received a patent for a device that would result in accolades in a completely different field. Lamarr, along with composer George Antheil, developed a "Secret Communications System," designing their device to assist in the efforts against the Nazis. This radio signaling mechanism would allow for the manipulation of radio frequencies during communications, creating an unbreakable code that could not be intercepted by the enemy. The importance of this invention was not fully realized until years later, when it was used to develop technologies for the military and became the security foundation for digital communications such as fax and cell phones. In 1997, fifty-six years after the invention of the device, Lamarr and Antheil received the Electronic Frontier Foundation Pioneer Award.

Hedy Lamarr was far from one-dimensional. She once said, "I can excuse everything but boredom. Boring people don't have to stay that way." Lamarr understood that rather than having to decide between being intelligent or glamorous, having intelligence was glamorous. We raise this toast to all glamorous, intelligent women!

Gin: The Original Flavored Vodka

Genever is made in pot stills primarily from malted barley, corn, wheat, and rye. The botanicals are immersed directly in the mash before it is distilled. Malted barley results in a full-bodied spirit.

Dry Gin is based on a neutral spirit that has been rectified through several distillations. The botanical flavors are typically added through three methods:

Steeping with neutral spirit in a pot still prior to distillation;

Infusion, by placing botanicals in a basket in the still that the vaporized spirit passes through, picking up flavors; or

Boiling, by combining botanicals with base spirit in a pot still just before distillation begins (rather like making a tea).

Old Tom Gin is a sweetened gin.

BRAINS & BEAUTY

YIELD: 1 cocktail

Glassware: chilled coupe glass

Garnish: small edible flower

INGREDIENTS

» 1 ounce (30 ml) Hendrick's Gin
» ½ ounce (15 ml) apricot liqueur
» ½ ounce (15 ml) fresh lime juice
» ½ ounce (15 ml) simple syrup
» 3 dashes apple bitters
» 1 ounce (30 ml) champagne

By Charlotte Voisey
William Grant & Sons USA, Brooklyn, NY

"Hedy Lemarr was known as the most beautiful woman in films in her heyday," says creator Charlotte Voisey, "but what few realize is that alongside that beauty was the brains that helped create a wartime coding system that still forms the backbone of encrypted communication today. I wanted this cocktail 'toast' to be loaded with flavor, well balanced, timeless, as well as pretty to look at."

DIRECTIONS:

Combine all ingredients except champagne in a shaker and shake well. Double strain into a chilled coupe glass, top with champagne, garnish with edible flower, and serve.

ROSALIND
- ELSIE -
FRANKLIN

(1920—1958), Scientist

—

Competition is the name of the game when it comes to medical research. Often, multiple teams of researchers around the globe are working toward finding the same discovery and then enjoying the notoriety that will come with it. Rosalind Elsie Franklin experienced this firsthand in the field of genetics.

Rosalind was raised in London and attended one of the few all-girls schools that offered chemistry and physics in its curriculum. The access to these fields had significant impact on her, and by the age of fifteen she announced to her father her intention to be a scientist. Rosalind received a Ph.D. in physical chemistry from Cambridge University, and in 1951 became a research assistant at King's College in London, leading one of two projects that was focused on DNA.

Rosalind used X-ray diffraction, a technique for determining atomic and molecular structures, combined with photography to take a series of photos that provided critical evidence regarding the structure of DNA. In 1953, Rosalind's colleague Maurice Wilkins disclosed her Photograph 51 to competing research scientists James Watson and Franklin Crick. This supplied them with the insight required to complete their theoretical model of the double helix structure of DNA, for which they received a Nobel Prize in 1962.

Rosalind left King's College in 1953 but was required to agree to the condition that she would not study DNA. She turned her attention to viruses, publishing seventeen papers in five years.

Rosalind died of ovarian cancer at the age of thirty-seven having never received credit for her discoveries in the field of DNA research. Today we lift our glasses, recognizing all that Rosalind Elsie Franklin has offered to the field of modern medicine!

> **Rosalind was raised in London and attended one of the few all-girls schools that offered chemistry and physics in its curriculum. The access to these fields had significant impact on her, and by the age of fifteen she announced to her father her intention to be a scientist.**

IRONIC

YIELD: 1 cocktail

Glassware: highball glass

Garnish: Himalayan pink sea salt and wide grapefruit peel

INGREDIENTS

» 1 ounce (30 ml) Hayman's Old Tom Gin

» 1 ounce (30 ml) Alessio Vermouth Bianco

» ½ ounce (15 ml) Salers gentiane liqueur

» 1 ounce (30 ml) grapefruit juice

» club soda

By Chandra Lam Lucariello
Southern Glazers Wine & Spirits, Honolulu, HI

Creator Chandra Lam made this cocktail "slightly bitter with a hint of salt to emulate how Rosalind must have felt, never receiving the recognition she deserved for her work." It's a riff on the Americano, with a summer-y element to it to make the drink a little lighter, because "by god, the girl deserved a break."

DIRECTIONS:

Pour liquors and juice into a highball glass. Fill with ice and top with club soda. Stir to combine. Garnish with Himalayan pink sea salt and a wide grapefruit peel, and serve.

(1882–1931), Painter
—

A t birth we are assigned identities based upon biology and societal constructs. These identities decide everything from the clothes we wear to the bathrooms we use. The true identifier to who a person is, however, cannot be seen with the eyes or appointed at birth. It's felt in our hearts, in our souls.

At birth, Lili Elbe was designated male and named Einar Wegener. She met her wife, Gerda Goetlieb, while studying art at the Royal Danish Academy of Fine Arts. It was the failure of one of her wife's models to appear that resulted in Elbe's awakening. Elbe was slender and slight of frame, so it was suggested that she sit for the session. In her diaries, Elbe recounts donning the stylings intended for the model, saying, "I felt much at home in them from the first moment."

In 1912, Elbe and Goetlieb moved to Paris, where they continued their unorthodox marriage

for a few years with Elbe attending social events as Einar's sister Lili.

Eventually the emotional strain of a dual existence took its toll. In 1930, Elbe was contemplating suicide when she learned of Dr. Magnus Hirschfield and the Institute for Sexual Research in Berlin. Elbe commenced a series of gender reassignment surgeries at the age of 47. The details of the surgeries are largely unknown, because the Nazis destroyed of the Institute's records in 1933, but it is known that the male genitalia was removed and there was a graft of two ovaries. Elbe desperately desired a family and went on to attempt a womb transplant, which resulted in her death in 1931.

Today the struggle continues for people to be able to express and live in their true identity. This toast is raised to Lili and all those who continue to fight for that right.

> That I, Lili, am vital and have a right to life I have proved by living 14 months. It may be said that 14 months is not much, but they seem to me like a whole and happy human life.
>
> —LILI ELBE

THE DANISH GIRL

YIELD: 1 cocktail

Glassware: coupe glass

Garnish: Amarena cherry

INGREDIENTS

» 2 ounces (60 ml) Bols Barrel Aged Genever

» ½ ounce (15 ml) Maurin Quina

» ½ ounce (15 ml) Malmsey Madeira

» 2 dashes chocolate bitters

By Kate Gerwin
Front & Cooper, Santa Cruz, CA

Imagining a night in the life of Lili Elbe, creator Kate Gerwin envisioned her "stretched out on her late nineteenth-century chaise, sipping slowly on this cocktail filled with worldly ingredients she had collected during some of her travels."

DIRECTIONS:

Stir all ingredients with ice. Strain into a coupe glass. Garnish with an Amarena cherry and serve.

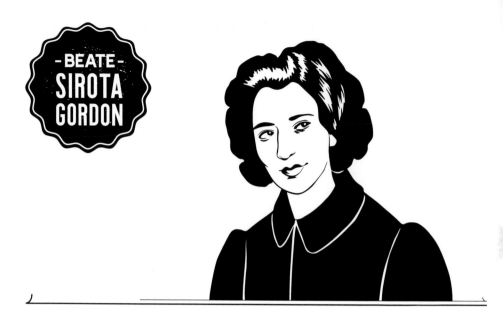

BEATE SIROTA GORDON

(1923—2012), Ambassador/Activist
—

The life of Beate Sirota Gordon is a compelling study in cause and effect. In the first twenty years of her life, a series of events created an opportunity for Gordon to change the course of history for the women of Japan.

Gordon was born in Vienna but spent most of her childhood in Japan, where her father, a concert pianist, was teaching and performing. In 1939, she headed to Mills College in Oakland, California, leaving her parents behind.

On December 7, 1941, the Japanese attacked Pearl Harbor, ending Gordon's contact with her parents and cutting off her source of support. Gordon put her talents in foreign languages to work, taking a position at a foreign listening post in San Francisco for the U.S. government. In 1945, Gordon became a United States citizen, the war drew to a close, and the whereabouts and welfare of her parents in Japan were still unknown. Gordon secured a job as an interpreter for General Douglas MacArthur's occupation army, and on Christmas Eve, the twenty-two-year-old

Gordon touched down as the first female civilian to arrive in post-war Japan. Her parents were located, having survived their wartime internment. Gordon continued her work with General MacArthur, whose first priority was to draft the Japanese constitution. The only woman on the General's team, Gordon was assigned to the subcommittee drafting the articles on civil rights for what would become the most progressive constitution in the world.

During her childhood in Japan, Gordon had witnessed how women were treated, saying, "Women had no rights whatsoever." She seized the opportunity to change that. Article 14 guaranteed equal rights, and Article 24 ensured marriage was an equal, consensual union and protected women in the rights to "choice of spouse, property rights, inheritance, choice of domicile, divorce and other matters pertaining to marriage and the family."

Cheers to Beate Sirota Gordon and the many Japanese feminists she inspired.

> **Gordon was assigned to the subcommittee drafting the articles on civil rights for what would become the most progressive constitution in the world.**

GOLDEN SPROUT

YIELD: 1 cocktail

Glassware: elegant rocks glass

Garnish: edible gold dust powder, edible flowers, and green tea leaves

INGREDIENTS

» 1 ounce (30 ml) Nikka Coffey Gin

» 1 ounce (30 ml) Bols green tea liquor

» 1 ounce (30 ml) matcha green tea

By Sumire Miyanohara
Bar Orchard, Ginza, Japan

Sumire Miyanohara sees Beate Sirota Gordon as an iconic and influential woman, describing her as a golden sprout that "continues to offer the fruits and flowers of freedom and choice to the women of Japan."

DIRECTIONS:

In a shaker, whisk gin and green tea liquor into green tea. Shake all ingredients and strain into a glass. Sprinkle gold dust over the foam. Arrange the glass on a plate with edible flowers and green tea leaves and serve.

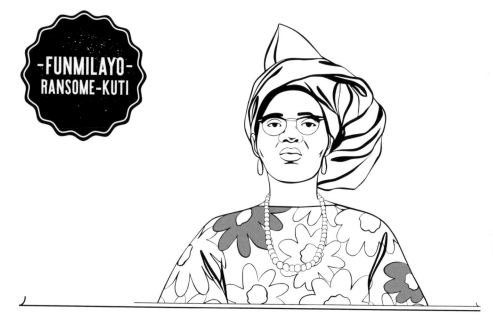

-FUNMILAYO- RANSOME-KUTI

(1900—1978), Activist

—

In the commercial hub of Abeokuta, Nigerian women were perceived as wealthy traders, and a flat tax imposed upon them for their gender was an important source of revenue for the colonial government. In October 1949, Funmilayo Ransome-Kuti, the mother of Nigerian feminism, led a 1,000-woman strong march to the royal palace of the Alake, the Yoruba King, to protest.

Ransome-Kuti, a teacher, was head of the Abeokuta Women's Union (AWU), an organization she founded in 1932 as the Abeokuta Ladies Club, a charitable and civic group made up of mostly Western-educated women. The club became increasingly politicized and, with market women joining its ranks, was reborn as the AWU in 1944. The women were disciplined and well organized, but their October 1946 protest was met with teargas and brutal beatings by authorities.

In 1947, the AWU released a list of grievances against the government's unfair and sexist practices.

That November, 10,000 women took to the streets and were again met with violence. The march resumed on December 8, with an excess of 10,000 women refusing to leave the palace for forty-eight hours, until the women arrested in November protests were released from prison, which finally happened on December 10th. The following spring, the Alake retreated to self-imposed exile.

Ransome-Kuti continued to campaign for women's suffrage and against colonial rule while advocating for democracy and for women's representation in government. She died in 1978 from injuries sustained when she was thrown out a window by soldiers ransacking her musician-activist son's home.

Ransome-Kuti is remembered for growing the AWU into one of the most impressive women's organizations of the twentieth century. It exceeded 20,000 members, sparking a women's movement that would radically transform the political structure of Abeokuta.

CHANGE-DRIVER

YIELD: 1 cocktail

Glassware: rocks glass

Garnish: lavender sprig

INGREDIENTS

» 1½ ounces (45 ml) Fords Gin

» ½ ounce (15 ml) Pierre Ferrand Dry Curaçao

» ¾ ounce (22 ml) Amaro Nonino

» ¾ ounce (22 ml) lemon juice

» 1 dash Bar Keep Lavender Bitters

By Andrea Tateosian
Kimpton Hotels, Washington, D.C.

Andrea's Change-Driver is a nod to Ransome-Kuti's role as a driver of social and political change in Nigeria, as well as an acknowledgement that she was the first female to drive a car in Nigeria.

DIRECTIONS:

Combine all in a shaker. Shake vigorously for about 15 seconds and strain into a rocks glass over fresh ice. Give a lavender sprig a hearty smack and place it in the glass. Serve.

WHISKY /
WHISKEY

For many years whiskey, like the saloon, was made to feel like a man's frontier. Today we still find ourselves being mansplained to when we attend whiskey events, but we remain undeterred. Ordering a whiskey neat or with one large rock might still be a conversation starter with the old guy at the bar, and we implore you to converse with confidence. Whiskey, like gin, has received a boon thanks to the cocktail revival, meaning it's a wonderful time to learn, experiment, and taste everything you see.

FLORENCE -FINCH-

(1915—2016), Activist

—

Frequently the biggest heroes are ordinary people tucked in the shadows. Such was the case with Florence Finch. Finch, known throughout her life as Betty, was born on the island of Luzon, the daughter of a Filipino mother and a U.S. Army veteran father. Upon graduating high school, she was hired as a stenographer at the U.S. Army headquarters in Manila, where she met her future husband, a U.S. sailor who was killed in action shortly after they married while attempting to resupply captured soldiers.

Betty claimed her Filipino citizenship to avoid internment during the Japanese occupation of Manila. Touting the skills she learned as a stenographer, she was able to procure a job with the Philippine Liquid Fuel Distributing Union. Her job writing gas rationing cards provided the perfect avenue for her clandestine work with the Philippine resistance movement, allowing her to divert fuel supplies to the underground and to sabotage shipments to the Japanese. During this time, Betty learned her former supervisor from her days as a stenographer, Major Englehart, was imprisoned. Through hidden messages, she learned of his mistreatment and began smuggling food, medicine, clothing, and soap to prisoners of war.

In October 1944, Betty was captured by the Japanese. She was imprisoned in a two-by-four-foot (0.6 x 1.2 m) cell, interrogated, and tortured. Through it all, Betty refused to divulge any information that would be beneficial to her Japanese captors. She was released in February 1945 weighing only eighty pounds.

After her release, Betty moved to Buffalo, New York, and joined the Coast Guard Women's Reserve. She rarely spoke about her experiences in the war, saying, "I feel very humble because my activities in the war effort were trivial compared with those of the people who gave their lives for their country." When her superiors in the Coast Guard learned of her activities and what she had endured, she was awarded the Asiatic-Pacific Campaign Ribbon and later the Medal of Freedom.

I feel very humble because my activities in the war effort were trivial compared with those of the people who gave their lives for their country.

—FLORENCE FINCH

BETTY FINCH

YIELD: 1 cocktail

Glassware: chilled 7-ounce (200 ml) coupe glass

Garnish: Orchid flower, smoked sea salt

INGREDIENTS

» 1½ ounces (45 ml) Belle Meade Bourbon

» 1 ounce (30 ml) Nigori sake

» ¾ (22 ml) ounce fresh pineapple juice

» ½ ounce (15 ml) coconut milk

» ½ ounce (15 ml) lemon juice

» ¼ ounce (8 ml) wildflower honey

By Megan Deschaine

The Macintosh, Charleston, SC

Megan Deschaine incorporated flavors of sweet (tamis), sour (asim), and salty (alat), traditional elements of Filipino cuisine, in her toast to Betty Finch. Although many would have been tempted to develop a tiki cocktail, Megan was compelled by Betty's humility "to try to create a cocktail with an understated subtlety and sophistication."

DIRECTIONS:

Shake all ingredients and double strain into a chilled coupe glass. Garnish with an orchid and a sprinkle of smoked sea salt. Serve.

JEANNETTE - RANKIN -

(1880—1973), Politician/Pacifist
—

It is commonplace for women to be peacekeepers in our day-to-day lives. Whether settling a dispute among young siblings or acting as Switzerland at the Thanksgiving table, we frequently find ourselves smoothing situations over. Jeannette Rankin took this to the next level, preaching the futility of war.

A Montana native, Rankin was the first woman to be elected to Congress. Her progressive platform included a constitutional suffrage amendment and social welfare programs. Upon election to the House of Representatives, Rankin stated, "I may be the first woman member of Congress, but I won't be the last!" Four days after taking her seat, she placed the first vote ever made by a woman in Congress against entering World War I. It was, she believed, her most important accomplishment, but it resulted in subsequent loss of her seat in 1918.

Rankin returned to the political races in 1940, running against an outspoken anti-Semite as the concern over war in Europe was rising. By her election, the war was full bore, bringing Rankin's pacifist activism to the forefront. The day after the attack on Pearl Harbor, the House and Senate met to deliberate U.S. involvement in the war. House Speaker Ted Rayburn of Texas refused to recognize Rankin as deliberations were taking place and eventually called her out of order. Despite efforts of persuasion bordering on harassment from other members of the House, Rankin held her ground and voted no amid what was described as a "chorus of hisses and boos," saying, "I can't go to war, and I refuse to send anyone else." This unpopular vote resulted in the rest of her term being essentially irrelevant.

Rankin continued to preach the gospels of peace and pacifism, eventually organizing the Jeannette Rankin Brigade, a group of some 5,000 feminists, radicals, pacifists, and students who marched on Washington, D.C., in protest of the Vietnam War.

I may be the first woman member of Congress, but I won't be the last!

—JEANNETTE RANKIN

RANKIN BRIGADE

YIELD: 1 cocktail

Glassware: 12 to 14 ounce (350 to 400 ml) julep cup

Garnish: large bouquet of mint

INGREDIENTS

» ¼ ounce (8 ml) Drambuie

» 1 heavy barspoon unsulphured blackstrap molasses

» 10 mint leaves

» 1½ ounces (45 ml) Wyoming Whiskey Small Batch Bourbon

» 1 ounce (30 ml) Spotted Bear Gin

By Meagan Schmoll
Tupelo Grille, Whitefish, MT

"Even when discouraged by pretty much everyone, she stuck by her convictions," says creator Meagan Schmoll, who was inspired by the perseverance of this Montana forebroad. *"The Rankin Brigade echoes Jeanette's independent, unconventional approach to life as a woman: strong, feminine, with a rich round edge."*

DIRECTIONS:

Place Drambuie, molasses, and mint in a julep cup. Lightly muddle the mint. With a spoon, coat the insides of the julep cup with muddled ingredients. Add remaining ingredients and fill halfway with crushed ice. Swizzle with spoon or swizzle stick, until outside of the cup is frosty. Add more crushed ice and repeat. Top with crushed ice. Garnish with mint and serve.

(Unknown—c. 1780), Revolutionary Spy

—

The mark of excellent intelligence officers is their ability to keep their identity unknown, something the mysterious Agent 355 has done for more than 200 years! Agent 355 was a member of the Culper Ring, a famous spy network that was instrumental in uncovering Benedict Arnold's plot to "sell" West Point to the British, which could have caused the defeat of General Washington.

The Culper Ring was formed by civilian residents of occupied New York in 1780 and helmed by Long Island farmer Abraham Woodhull, who ran the operation under the codename "Samuel Culper, Sr." Robert Townsend, a dry goods merchant, was a key agent posing as his son with the codename "Samuel Culper, Jr." Some guess that Agent 355 was Robert Townsend's common-law wife. In the organization's elaborate code, 355 meant "lady," a term reserved for women from well-heeled families, or those who were educated. Identifying informants by social strata was key, as grooms or housemaids could provide vastly different intelligence than their high-society counterparts.

From the quality of information Agent 355 delivered, many historians believe her to be from or connected to a prominent Tory family, allowing her access to New York's British and military elite. She was a main source of intelligence regarding the movements of Major John Andre, a debonair bachelor and head of British Intelligence Operations in New York with "a weakness for women." Brian Kilmeade and Don Yaeger imagine her in their book *George Washington's Secret Six* as "part of the glittering, giggling cluster of coquettes who flocked around Major Andre," suggesting that Agent 355 worked the room at his parties, gleaning as much as she could from his ale-addled conversations.

Major John Andre was hanged by General Washington for treason and Benedict Arnold's plan was uncovered, thanks in great part to the intelligence this mysterious operative delivered.

Cheers to the brave and mysterious Agent 355!

Whisky, Whiskey, White Dog . . . WTF?

Whiskey, in broad strokes, is grain spirit distilled from a fermented mash of grains then aged long enough in oak to take on characteristics of the barrel. The mash bill, regional water, barrel make/char, and aging location all affect the taste of the final product. Throughout this chapter, we provide a primer to help you decode the whiskey aisle.

Rye whiskey by law must contain 51% rye grain in the mashbill and be aged in charred, new American oak barrels. Rye was the favored spirit of colonial America, first made stateside by Scots-Irish immigrants who imported the grain. Despite the harsh Northeastern climate, hardy rye flourished, making it a perfect go-to ingredient for early American hooch.

AGENT 355

YIELD: 1 cocktail

Glassware: 9-ounce (270 ml) rocks glass

Garnish: orange twist speared with clove

INGREDIENTS

» 1½ ounces (45 ml) Sazerac Rye whiskey

» 1 ounce (30 ml) Laird's Bonded Applejack brandy

» 1 barspoon Steen's cane syrup

» 4 dashes Bitter Truth aromatic bitters

» Velvet Falernum rinse

By Kimberly Patton-Bragg
Latitude 29, New Orleans, LA

Kimberly used some of America's oldest spirits, Laird's apple brandy and rye whiskey, to toast revolutionary Agent 355. Big, bold, and boozy, this is the cocktail that will help an undercover broad "glean information from her foes."

DIRECTIONS:

Combine rye, brandy, cane syrup, and bitters with ice in a mixing glass and stir. Rinse a chilled rocks glass with Velvet Falernum and discard. Strain into prepared glass and garnish with orange twist speared with clove. Serve.

- MARIE -
THARP

(1920—2006), Scientist
—

W ould you believe that one of the most important scientific discoveries of the century was initially dismissed as "girl talk?"

Despite having master's degrees in both geology and mathematics, when Marie Tharp was hired at the Lamont Geological Laboratory at Columbia University, it was to work as a research assistant. Her male bosses were younger than her and had fewer credentials.

Tharp collaborated with Bruce Heezen to map the entire ocean floor using sonar records, earthquake epicenters, salinity measurements, and other types of data that would be considered rudimentary today. As a woman, she was not permitted on naval ships, so Heezen collected data while she drafted. Tharp discovered a 40,000-mile (64,370 km) long mid-ocean ridge that circles the Earth, a discovery critical to the theory of plate tectonics, then a revolutionary and controversial idea. Her discovery and conclusions were at first dismissed as "girl talk;" Heezen went on to publish it as his own work and take credit for it.

"I was so busy making maps, I let them argue," said Tharp of the controversy. "I figured I'd show them a picture of where the rift valley was and where it pulled apart. There's truth to the old cliché that a picture is worth a thousand words and that seeing is believing." The team mapped the entire ocean floor between 1952 and 1977, but when Heezen died, Tharp was no longer able to get funding to do her work. Still, she contributed tons of information to our knowledge of the planet. As one biographer describes it, if the Earth were a football, before Tharp we only knew what the laces looked like.

"The whole world was spread out before me," said Tharp. "I had a blank canvas to fill with extraordinary possibilities . . . It was a once-in-a-lifetime—a once-in-the-history-of-the-world—opportunity for anyone, but especially for a woman in the 1940s."

Cheers to "girl talk!"

EXTRAORDINARY POSSIBILITIES

YIELD: 1 cocktail

Glassware: 10- to 12-ounce (300 to 350 ml) rocks glass

Garnish: lemon oil

INGREDIENTS

» 2½ ounces (75 ml) Bowmore 12 Year Old Scotch whisky

» ½ ounce (15 ml) Briottet Creme de Noisette Hazelnut Liqueur

» ½ ounce (15 ml) honey syrup

» 8 dashes Hella Citrus Bitters

By Robin Nance
Beam Suntory, Chicago, IL

Modern-day Scotch maven Robin Nance was inspired by Tharp's groundbreaking work "at a time when women weren't supposed to be working, much less changing the world." Her "riff on the quintessential 'manly drink,' the Old Fashioned," uses "the peat and salinity in Bowmore 12 to represent Tharp's geology work as well as her groundbreaking oceanic sonar."

DIRECTIONS:

Place all ingredients in a mixing glass with ice and stir. Strain into rocks glass over a large cube or sphere of ice. Garnish with lemon oil.

MARJORIE - HILLIS -

Live Alone and Like It

(1889—1971), Author

—

Marjorie Hillis's *Live Alone and Like It* debuted in 1936, topping the nonfiction bestseller list and selling 100,000 copies in a year. The 1930s were a boon for self-help books: With the Depression and political unrest in Europe, Americans were eager to be told things would be okay. But Hillis was the first mainstream American writer to concern herself with the happiness of the single woman.

Hillis's parents were also writers. Her mother, Anne Louise Patrick, wrote a book, *The American Woman and Her Home*, espousing that true happiness was only found through marriage. (Hillis's apple fell a little further from the tree.) Her father, Dr. Newell Dwight Hillis, was a preacher who published his sermons in the *The Brooklyn Daily Eagle*. Hillis was devastated when they tragically died within one year of each other.

After packing up their suburban home, Hillis moved to New York, where she was a writer and editor at *Vogue* and cultivated the life that would be a blueprint for her book. *Gone with the Wind* topped the fiction charts as Hillis's book was skyrocketing to non-fiction success. She went on to become a popular lecturer, speaking before large audiences around the country. She devoted an entire chapter to "A Lady and Her Liquor."

Hillis married in 1939 and was criticized for it; however, her book was never intended as a "brief in favour of living alone," but rather a rallying cry that, although the choice to be alone in the moment may not be yours, the choice to be happy while living alone is. She commented that a solitary existence was again likely "even if only now and then between husbands."

"You have got to decide what kind of a life you want and then make it for yourself," wrote Hillis.

But anybody ought to be able to master the recipes for Martinis, Manhattans, and Old Fashioneds without undue strain. Having mastered them, do not try to improve on them. You can't.

— MARJORIE HILLIS

SEARED IN MEMORY

YIELD: 1 cocktail

Glassware: 12-ounce (350 ml) double Old Fashioned glass

INGREDIENTS

» 1½ ounces (45 ml) Famous Grouse blended Scotch whisky

» ¼ ounce (8 ml) Cruzan Black Strap Rum

» ¾ ounce (22 ml) Seared Pineapple Syrup (see below)

» ¼ ounce (8 ml) fresh squeezed lemon juice

» 2 dashes Pernod

Seared Pineapple Syrup

YIELD: about 3 cups (700 ml)

» 1 ripe pineapple

By Brittany Fells
The Rose, Jackson, WY

Brittany Fells bucks convention with this toast to Hillis: a cocktail using pineapple juice that is stirred rather than shaken. "Although Hillis's cocktail advice was not to deviate from the norm, she rarely followed her own advice. This drink is rich and complex, much like I imagined her to be."

DIRECTIONS:

Combine ingredients with ice in a mixing glass and stir. (That's right, stir.) Strain into a double Old Fashioned glass over a large ice cube. Serve.

Syrup

Preheat oven to 350°F (175°C, gas mark 4). Skin and slice pineapple. Spread slices on a baking sheet. Roast, flipping once if necessary, for 30 to 60 minutes, until caramelized. Cool completely and juice.

RUBY NELL BRIDGES HALL

(1954–), Activist

—

By November 1960, the Louisiana State Legislature's tactics to delay public school integration were exhausted. On November 14, despite their efforts, six-year-old Ruby Nell Bridges Hall became the first and only black student to integrate New Orleans' all-white William Frantz School, stepping into history.

Ruby was one of many students who took a test to determine whether she could attend the white school located just five blocks from her home; her all-black segregated school was several miles away. The test was written to be exceptionally challenging, and Ruby was one of six children who passed it.

Four U.S. Marshals accompanied Ruby on her first day. Dressed in a pretty white dress, this brave and tiny trailblazer with an infectious smile was greeted by an angry mob of more than 200 white parents, who hurled objects and insults. Marshal Charles Burks recalls that Ruby never cried or whimpered: "She just marched along like a little soldier." The furious families staged a boycott, pulling their children out of school; no one in Ruby's class would return for the entire year. Barbara Henry, a recent transplant from Boston, taught Ruby, sitting in a desk beside her as they worked on her lessons in the empty classroom. A woman threatened to poison Ruby on her second day of school, so federal marshals decreed she could only eat food from home, which Ruby did alone in her classroom until January. (When she started to exhibit signs of panic and stress, Mrs. Henry joined her for lunch.) Another morning Ruby was "greeted" by a woman displaying a black doll in a coffin. Nevertheless, neither Ruby nor Mrs. Henry missed a single day of school.

Psychologist Robert Coles, who worked with Ruby pro bono that year, recalls a morning when Ruby stopped in front of the mob, lips moving. As he learned later, little Ruby wasn't responding to the people, she was talking to God. "Well don't you think they need praying for?" she told him. "I pray for them every morning and I pray for them every afternoon when I go home. I always say 'please dear god, forgive them because they don't know what they're doing.'"

In 1999, Ruby founded the Ruby Bridges Foundation. Through education and inspiration, the foundation hopes to end racism and prejudice. Their motto is one we'd like to write across the sky: "Racism is a grown-up disease and we must stop using our children to spread it."

May we all live to see that motto manifest!

Irish whiskey is made in diverse styles nowadays, but for generations could be understood as either made from malted barley or a mixture of malted and unmalted barley called "pot still" and other cereals. Traditional Irish whiskey was triple-distilled, aged in oak casks for minimum three years, and then blended. These days, anything goes!

STEP BY STEP

YIELD: 1 cocktail

Glassware: 6-ounce (180 ml) coupe glass

Garnish: sprig of fresh thyme

INGREDIENTS

» 1½ ounces (45 ml) Egan's Vintage Grain Irish Whiskey

» 1 ounce (30 ml) Spanish dry vermouth

» ¾ ounce (22 ml) ginger liqueur

» ¾ ounce (22 ml) lemon juice

» ½ ounce (15 ml) cane syrup

» absinthe rinse

By Abigail Gullo
Compere Lapin, New Orleans, LA

Abigail Gullo's Step by Step is named for "The Ruby Bridges Suite," a spoken word, musical, and choir piece inspired by Ruby and her courageous steps. Gullo uses ingredients representing the many cultures that meet to create the beauty of New Orleans, with a garnish of fresh thyme, which since ancient Greece has symbolized courage, bravery, and strength.

DIRECTIONS:

Shake whiskey, vermouth, ginger liqueur, lemon juice, cane syrup, and ice in a shaker. Rinse coupe with absinthe. Strain cocktail into coupe glass, garnish with thyme, and serve.

KATHERINE
- DUNHAM -

(1909–2006), Dancer/Scholar

—

"T riple threat" is a term used to describe an exceptionally talented entertainer who is adept at acting, singing, and dancing. Add scholar and anthropologist to that list and you've just scratched the surface of tour de force Katherine Dunham.

Born in Chicago to an African-American father and a French-Canadian mother, Dunham would probably have kept to singing gospel music if her church hadn't fallen on hard times. At just eight years old, she announced she would host a "cabaret," despite scarcely knowing what the term meant, to help raise funds. She amazed and scandalized the church with her non-religious performance.

Hoping to become a school teacher, Dunham became the first African-American woman to attend the University of Chicago, where she earned bachelor's, master's, and doctoral degrees in anthropology. After college she founded the Negro Dance Group, from which she was "discovered" by Mrs. Alfred Rosenwald Stern, who offered to fund any study benefitting Dunham's dance career. Dunham set off on a two-year trip to the Caribbean, where she was profoundly influenced by dance and ritual, finding special resonance in Haitian culture.

Back stateside, Dunham revolutionized dance in the 1930s. Caribbean and African culture influenced her choreography, blowing the minds of the Euro-centric dance world. Her presence dominated the stage, "an unmitigated radiant force." Her 1939 breakout successes "Tropical Revue" and "Le Hot Jazz" were intended as one-night-only events but went on for thirteen weeks!

Dunham's dance company toured for more than two decades, thrilling post-war European audiences with her revolutionary style. In 1963, she became the first African-American to choreograph for the Metropolitan Opera.

Throughout her illustrious arts career, Dunham remained a tireless activist, refusing to perform at segregated theaters. She started the Performing Arts Training Center in East St. Louis, IL, where she counseled disadvantaged youth. She famously went on a forty-seven-day hunger strike in 1992 at the age of 82 to protest the repatriation of Haitian refugees.

Dunham's techniques took the dance world by storm, but as she describes, "We weren't pushing black is beautiful. We just showed it."

Cheers to you, La Danseuse!

LA DANSEUSE

YIELD: 1 cocktail

Glassware: coupe glass

Garnish: skewered Luxardo cherries with long orange zest ribbons wrapped around them

INGREDIENTS

» 2 ounces (60 ml) Elijah Craig Small Batch bourbon

» 1 ounce (30 ml) Spice-Infused PAMA (see below)

» 3 dashes Regan's Orange Bitters

Spice-Infused PAMA

YIELD: about 3 cups (700 ml)

» 1 orange

» 2 tablespoons (11 g) whole cloves

» 2 tablespoons (12 g) whole allspice

» 3 cinnamon sticks

» 1 teaspoon (3 g) whole pink peppercorns

» 3 cups (720 ml) PAMA

By Lynn House
Heaven Hill Brands, Chicago, IL

Lynn House created her ode to Dunham on a "strong brown base in honor of a strong brown woman." This beautiful three-ingredient cocktail "is elegant and the garnish, while intricate, is also simple, just as a pas de deux should be."

DIRECTIONS:

Combine ingredients in a mixing glass with ice and stir. Strain cocktail into a coupe glass and garnish with the "dancing" orange twist and Luxardo cherries. Serve.

Spice-Infused PAMA

Cut orange into thin slices. Place orange slices and dry ingredients in a nonreactive or glass container, cover with PAMA, and allow to macerate for 24 hours. Pour infusion through a fine strainer to remove any solids. Bottle and keep refrigerated up to 3 months.

CLELIA - DUEL - MOSHER

(1863—1940), Scientist

—

Clelia Duel Mosher was one of the first female surgeons in America, and she provided an important body of research offering proof that women are not, in fact, inferior to men. Yes, Mosher would prove, women breathe through their diaphragms too.

Mosher suffered from tuberculosis as a child, which may have made her more attuned to the ways in which women's corsets inhibited such physical activities as breathing. Her father, Cornelius Mosher, was a man before his time who respected women's education and encouraged her to read literary works, attend artistic performances, and pursue her interest in science. He was also concerned about her going to college, for fear of complicating her health. She went anyway.

Mosher worked as a horticulturalist to save her money for college, enrolling at twenty-five years old at Wellesley College. She transferred to the University of Wisconsin and dug into her first research into human sexuality. She completed bachelor's and master's degrees at Stanford, and in

1900 Mosher graduated from Johns Hopkins School of Medicine, becoming one of the first female surgeons in America.

In 1910, Mosher became a professor at Stanford University, where her research focused on disproving the myth that women were "the weaker sex." She proved that the "monthly disability" that affected half the population was the result of constrictive clothing, inactivity, and the assumption that pain always accompanied menstruation.

Some of Mosher's most fascinating research included a series of surveys examining Victorian women's sex lives. Mosher questioned forty-five women about their sexual attitudes and practices, sexual desire, orgasms, and fertility control. As it happens, our Victorian sisters were not nearly so prudish as the social mores of the day suggest.

Here's to finding our pulse, Clelia!

Scotch whisky (they drop the e) is made from malted barley, or barley that has been germinated to convert the starches into a simple sugar. All Scotch whisky must be matured in oak casks for a minimum of three years; single malt whisky must be matured for a minimum of eight years. Scotland can be divided into five major regions: Highlands/Speyside, Campbeltown, Islay, The Islands, and The Lowlands. Although all Scotches have distinctive qualities, those produced in the same region tend to share distinctive characteristics.

YIELD: 1 cocktail

Glassware: 6- to 8-ounce (175 to 235 ml) Old Fashioned glass

Garnish: orange and lemon zests

INGREDIENTS

» 1½ ounces (45 ml) Jim Beam Rye

» ½ ounce (15 ml) Clear Creek Apple Brandy

» ½ ounce (15 ml) Chicory and Cardamom-Infused Maple Syrup (see below)

» 2 to 3 dashes of Bittermens Buckstrap bitters

Chicory and Cardamom–Infused Maple Syrup

YIELD: about 9 ounces (265 ml)

» 3 or 4 green cardamom pods

» 6 ounces (175 ml) maple syrup

» 3 ounces (90 ml) chicory

» zest of 1 orange

» zest of 1 lime

By Elizabeth Powell

T.C. O'Leary's, Portland, OR

Don Mega takes its name from a hip-hop phrase for something that's the best. "There is still some sort of idea that fruity, pink, and sweet drinks are 'girly' and that women don't do whiskey," says creator Elizabeth Powell. "I think that if Clelia were alive today, she'd be kicking back with a dark spirit, probably neat, after a long day dispelling myths about our gender."

DIRECTIONS:

Stir all ingredients over ice. Strain into an Old Fashioned glass. Garnish with orange and lemon zests and serve.

Syrup

Toast cardamom pods. Combine all ingredients in a pan and bring to a soft simmer. Let cool and strain.

(1935–), Musician
—

Behind our favorite singers there are armies of session musicians, without whom the lush sounds of studio recordings would not be possible. Working for an hourly or per-song rate, the legacy of these musicians is often little more than tiny text in the liner notes. One of them, bassist Carol Kaye, was one of the most prolific session players of the 1960s. She provided the bass line on thousands of recordings, including "La Bamba" by Richie Valens, the Righteous Brothers' "You Lost that Lovin' Feeling," and Sonny and Cher's "I've Got You Babe."

Raised near Port Angeles, Washington, by musician parents, Carol described her upbringing as poor but said that "when music was played, you had a sparkle in your life." She began her career playing the guitar and was playing and teaching professionally by the age of fourteen. While playing bebop guitar in the jazz club circuit of Los Angeles, Kaye met Bumps Blackwell, Sam Cooke's manager.

Impressed by what he heard, he hired her for studio work. She picked up the guitar's deeper cousin when a bassist no-showed at a session at Capitol Records. At first leery of the transition, Carol soon realized the bass allowed her more latitude to improvise her own lines and charts. At the same time, the jazz scene in Los Angeles was slowly diminishing, with the top clubs shuttering, resulting in a slow shift to the studio.

It's believed that Kaye performed on more than 10,000 songs during her fifty-year career. Although the work could at times seem isolating compared to club gigs, Kaye witnessed something very powerful. As the Vietnam War, racial strife, and political assassinations were taking place outside the studio, she and her fellow musicians "were all affected by such dramatic changes in the world, the music reflects that."

WICHITA LINEMAN

YIELD: 1 cocktail

Glassware: iced collins glass

Garnish: pineapple fronds

INGREDIENTS

» 1 ounce (30 ml) bourbon

» 1 ounce (30 ml) pineapple juice

» 1 ounce (30 ml) Aperol

» ½ ounce (15 ml) lemon juice

» 1 ounce (30 ml) soda water

» Cava (sparkling white wine), cold

By Josey Packard

Bar Mezzana, Boston, MA

*Josey Packard studied music as an undergrad, so she feels
"a special respect for Ms. Kaye and her success in making
music both her vocation and her avocation." This cocktail
is an ode to one of the most successful tracks Kaye played
on. In Josey's words, "What's more rock and roll than a
bourbon-based highball?"*

DIRECTIONS:

Assemble all non-carbonated ingredients in a shaker with ice
and briefly agitate to mix flavors. Strain into an iced collins
glass. Add soda water and fill remaining space with Cava.
Arrange pineapple fronds along one side of the glass, add a
straw, and enjoy.

HELEN "DIRTY HELEN" CROMWELL

(1886–1969), Speakeasy Owner

—

Dirty Helen is one of our favorite saucy broads of yore. Born Helen Cromwell into a wealthy family in Cicero, Indiana, her story starts like that of many a midwestern girl. Lured by love, Helen moved to Cincinnati against her father's wishes to marry when she was in her early twenties. Sometimes "daddy knows best" is accurate, and for Helen, this was the case with her first husband: While pregnant with her second child, her husband took up with Cincy's most prominent madam. After a heated confrontation, Helen left and never looked back.

Helen traveled the country from San Francisco to New York, making ends meet via the world's oldest profession, until finally placing roots in Milwaukee, Wisconsin. In 1926, she spent $300 to purchase the Sunflower Inn, a no-nonsense watering hole with rooms on the second floor, allowing her to offer multiple services. Using the contacts of her good friend Al Capone, the Sunflower Inn was outfitted with a concealed beverage serving system that allowed her to operate unhindered by the authorities throughout Prohibition. Egalitarianism was the name of the game at the Sunflower Inn as there was no furniture, meaning guests could either stand at the bar or plop on the plush carpeting. There were only two choices, House of Lords Scotch and Old Fitzgerald Bourbon, both of which were delivered regularly to the back door by taxi. If guests asked for something outside of the minimal menu, they would be lambasted by Helen's notoriously colorful admonishments, only to be rewarded moments later with a free drink for being such a good sport. Helen served gangsters, millionaires, socialites, famous sportsmen, and just plain people at the Sunflower Inn until its foreclosure in 1959.

Helen passed away at the age of eighty-three penniless but leaving a million-dollar legacy.

DIRTY DIAMOND

YIELD: 1 cocktail

Glassware: flute or coupe glass

Garnish: lemon twist

INGREDIENTS

» sugar cube

» Peychaud's bitters

» Angostura bitters

» 1 ounce (30 ml) rye whiskey

» 1 ounce (30 ml) Cognac

» 1 to 2 barspoons absinthe, to taste,
plus more to rinse glass

» champagne

By LeNell Camancho Santa Ana

LeNell's Beverage Boutique, Birmingham, AL

Helen labored for years under the burden of a broken heart after her first husband broke it foolin' around. She was introduced to Sazeracs the night she stepped out on the town in a red dress and the very diamond ring her husband gifted to the other woman: "discovered in New Orleans and made New York style—to make you forget your troubles." LeNell Camacho Santa Ana created this toast, "a New York–style Sazerac with both brandy and whiskey mixed in a diamond fizz style with champagne" to celebrate Helen and the night she woke up to liberate her broken heart.

DIRECTIONS:

Saturate sugar cube with bitters and muddle to dissolve. Add whiskey, Cognac, and absinthe. Rinse flute or coupe glass with absinthe. Stir contents of mixing glass with ice and strain into prepared glass. Top with champagne. Garnish with lemon twist and serve.

MARGUERITE ALICE "MISSY" LEHAND

(1896–1944), Political Advisor

—

Today our nieces grow up watching strong female legislators advocate for the rights of women and children, but some of the most important women working in politics in the past were relegated to working behind the scenes. Such was the case with Marguerite "Missy" LeHand, personal assistant to and confidante of President Franklin Delano Roosevelt for more than twenty years.

During her first few years with the Roosevelts, Missy had very little contact with FDR; she worked as support for his advisors during his bid for the vice presidency. After the unsuccessful run, Missy was asked by Eleanor Roosevelt to stay on with the family to wrap up outstanding correspondence associated with the election season. It was during this time that Missy and FDR built a working relationship that would endure for decades.

When FDR was elected president, Missy became the first woman to hold the role of Secretary to the President. This was a role that encompassed everything from gatekeeper to policy advisor; it was more similar in scope and importance to the modern-day chief of staff than to a traditional secretary. In her book *The Gatekeeper*, Kathryn Smith describes Missy as "the Swiss Army Knife of the White House. A formidable, multitalented multitasker."

In 1941, Missy collapsed at a White House event from a stroke; she had suffered heart complications throughout her life. She moved back into her apartment at the White House after leaving the hospital but was unable to return to her duties at the President's side. She passed away three years later. In his statement upon her passing, President Roosevelt described Missy as "faithful and painstaking, with charm of manner and inspired by tact and kindness of heart, she was utterly selfless in her devotion to duty."

To Missy and all women who work with tireless integrity behind the scenes!

Bourbon whiskey shares a similar template for production as rye, but in this case corn accounts for no less than 51% of mashbill. Corn makes a sweeter spirit than rye; as Robert Hess says, "I'd never have a Reuben sandwich on cornbread." Bourbon can be made anywhere in the U.S., but is most commonly associated with Kentucky.

Canadian whisky is commonly perceived as a rye-based spirit, but in its modern incarnation, it is usually based on corn, with rye and barley added to the mix. There are no legal stipulations about mashbill, blending, and distillation. Canadian whiskies must be aged for at least three years; however, most are aged between six and eight years. Some of the mash is distilled to a very high proof, essentially making it a neutral grain spirit, but this still must be aged for at least three years.

RIGHT HAND

YIELD: 1 cocktail

Glassware: Nick & Nora glass

Garnish: orange oil

INGREDIENTS

» 1½ ounces (45 ml) Eagle Rare bourbon

» ½ ounce (15 ml) Arkansas Black brandy

» ½ ounce (15 ml) Suze liqueur

» ½ ounce (15 ml) cinnamon demerara syrup

» 2 dashes Fee Brothers Walnut Bitters

By Nicole Lebedevitch

Yvonne's, Boston, MA

To honor the "Swiss Army Knife of the White House," Nicole Lebedevitch was inspired to combine some spirits—bourbon and apple brandy—to create a strong backbone for a drink with a soft and almost warming flavor. "Missy was strong, comforting, but meant business and got it done," says Nicole.

DIRECTIONS:

Combine all ingredients in a mixing glass with ice and stir. Strain into a chilled Nick & Nora glass and garnish with orange oil. Serve.

- RITA -
TAKETSURU

(1896—1961), Distillery Founder

—

In 1918, Jessie Roberta "Rita" Cowen was reeling from misfortune: Her fiancé was killed in the Great War, and her father died unexpectedly from a heart attack. Struggling to support their family, her mother took in a university student as a boarder. Masataka Taketsuru was studying organic chemistry while apprenticing at Scotch distilleries with dreams of opening a whisky distillery in Japan. Masataka and Rita quickly fell in love, setting Rita on the path to becoming the mother of Japanese whisky.

In 1920, Rita and Masataka married without ceremony, against the wishes of their parents, and moved to Japan, where Rita gave lessons in English and piano to support her husband's pursuits. Through her lessons, she met the founder of a securities company who, upon hearing of Masataka's ambitions, decided to invest in the distillery.

Nikka distillery was built in Yoichi on the island of Hokkaido because of its similarity in climate and environment to Scotland. Rita devoted her time to assimilating to Japanese culture, learning as much as possible about the language, cuisine, and traditions. With the onset of World War II, suspicion of foreigners grew. Many believed that Rita was a spy, and she was accused of sending messages to the British due to the existence of an antenna on their house, which was frequently searched for radio equipment. But the war also resulted in significant growth for Nikka whiskey; bans placed on the import of foreign goods included distilled spirits, so the distillery was classified as part of the war industry to ensure that sailors had their daily rations.

Through racism and war, Masataka and the staff of Nikka remained supportive of Rita, and she was beloved within the community of Yoichi. Her legacy is easily felt today as one walks down Yoichi's main thoroughfare, Rita Road.

> **Masataka and Rita quickly fell in love, setting Rita on the path to becoming the mother of Japanese whisky.**

UISUKI COCKTAIL

YIELD: 1 cocktail

Glassware: 10- to 12-ounce (300 to 350 ml) rocks glass

INGREDIENTS

» 1 ounce (30 ml) Nikka Taketsuru Pure Malt Japanese whisky

» 1 ounce (30 ml) Rhine Hall La Normande Pommeau

» 1 ounce (30 ml) Cocchi Vermouth di Torino

By Julia Momose
Oriole, Chicago, IL

While their first batch of whisky was resting in barrels, the Taketsurus produced "apple wine" and apple brandy to support the business. Julie Momose crafted this cocktail to bring together whisky and wine: "I would like to raise a glass to her quiet strength, humility, and cleverness."

DIRECTIONS:

Place a large piece of crystal clear ice in the base of your glass. Measure ingredients over the ice and give a gentle stir to incorporate. Take a sip before much dilution occurs, gradually tasting the way the ingredients weave in and out as they sit and swirl over the ice.

PAIGE AUBORT

(1989—),
Bartender/Community Organizer
—

One of the most important components of the Toast Club is creating a community of women to mentor and support one another, so we were thrilled when a bartender we approached to contribute suggested a cocktail to toast her own mentor! Paige Aubort has selflessly helped women throughout the bartending community in Australia. With accolades aplenty, including being named to the 2017 list of Forbes' 30 under 30 in Asia, it is obvious to all that Paige is a bartending powerhouse. Her desire to have the stars of the women around her rise in conjunction with her own sets her apart.

In 2016, Aubort founded Coleman's Academy, named after our bartending fore-broad Ada Coleman, who helmed the bar at the famed Savoy Hotel in London for more than twenty years. A women's organization for bartenders, Coleman's Academy focuses on the ideals of mentorship through connecting women within the community, educating about the history of women within the bartending industry, creating a collaborative environment for strengthening the role of women bartenders, inspiring women to pursue their goals, and cultivating a community that works towards collectively advancing women in the industry.

As bartenders, taking care of people is our vocation, but Paige's instinct to cultivate and care for those around her is natural and inherent. Paige's ten-year goals include the not-so-unusual desire to own her own business and the dream of organizing a program to give back to her community. Well, Paige, you are already doing that—this toast is for you!

Applejack is an apple brandy and America's oldest spirit, popular during colonial times. The first commercial producer, Laird's & Company, was founded by a Scotch-maker who used the abundance of apples in Monmouth, New Jersey, to make hooch when he opened the nation's first distillery in 1780. General Washington even borrowed the recipe to try his own hand at distilling at Mount Vernon. Today, Laird's is helmed by Lisa Laird Dunn, the ninth generation to head up the company, an inspiration to us all!

Moonshine is a spirit made via an unlicensed still; it is also known as white lightning, mountain dew, firewater, hooch, and many other names, all of which sound risqué and totally illegal. Although the term technically describes any spirit made illicitly, or "by the light of the moon," in the U.S., moonshine typically denotes unaged or white whiskey bottled in a mason jar and hailing from Appalachia or someplace south of the Mason-Dixon line.

PINEAPPLE YAAS QUEEN

YIELD: 1 cocktail

Glassware: chilled wine glass

Garnish: edible flower

INGREDIENTS

» 1½ ounces (45 ml) Tullamore Dew Irish whiskey

» 2½ ounces (75 ml) Pineapple Tepache (see below)

Pineapple Tepache

YIELD: 5 cups (1.2 L)

» 1 cup (180 g) brown sugar
» 1½ cups (350 ml) water
» 1 pineapple cut into chunks, skin on
» 1 cinnamon stick
» 5 cardamom pods
» 5 cloves
» 1 thumb of Ginger, crushed with a knife

By Cherish Wilkie

Ramblin' Rascal Tavern, Sydney, Australia

Cherish Wilkie met inspirational lady Paige Aubort at Lobo Plantation, which is known for pineapples, the universal symbol for hospitality. Cherish chose pineapple tepache because "it's a bit fun, a bit sweet but spicy like Paige."

DIRECTIONS:

Pour whiskey then pineapple tepache into wine glass. Top with ice and place an edible flower in the glass. Serve.

Pineapple Tepache

Combine sugar and water in a 64-once (1.9 L) fermentation jar. Shake until dissolved. Add remaining ingredients and muddle. Top with water, if needed, to three fingers from the top of the jar. Leave at room temperature for 2 to 3 days, tasting every day until the liquid turns cloudy or the taste is to your liking.

Strain, keeping the contents of the jar.

Repeat the fermentation process by adding ½ cup to 1 cup (90 to 180 g) more brown sugar and fill with water again. Follow the steps above.

RUM

Few spirits inspire the mind to such flights of fancy as rum. Rum was de rigeur in the colonial era publick house, whet the whistles of thirsty travelers traipsing through the Caribbean during Prohibition, and is essential to the exotic drinks that defined the tiki trend. What follows are modern rum drinks that mimic their forebears, running the gamut from straightforward sips made with just a few ingredients to a tiki drink stacked tall with spirits.

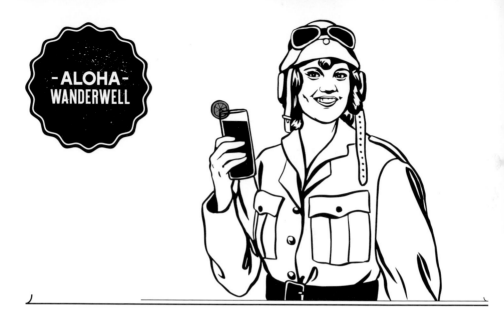

-ALOHA-
WANDERWELL

(1906—1996), Explorer

—

We all spend our young lives dreaming of travel and adventure, but how many of us would be bold enough to answer a Parisian newspaper ad promoting "Brains, Beauty and Breeches—world tour offer for lucky young woman"?

At the age of sixteen, Idris Galcia Hall did just that, applying to be the secretary and driver for an around-the-world expedition helmed by "Captain" Walter Wanderwell. Taken by her spirit and wanderlust, Captain christened her Aloha Wanderwell and invited her to join the ranks of his Work Around the World Expedition Club (WAWEC). Fluent in multiple languages, Idris was well suited to assist in the adventures ahead. Using kerosene for gas, crushed bananas for grease, and elephant fat for engine oil, their Ford Model T would take Aloha and the WAWEC to forty-three countries, making her the first woman to drive around the world! "People cannot comprehend—could never understand me—I'm sure. Something impelled this wanderlust. I would not be detained."

Eventually Aloha and the Captain married, but they did not settle down. They continued their adventures, traveling to the Amazon, where their plane went down in uncharted jungle. With no other recourse, Captain began his trek for help, leaving Aloha with the indigenous Bororo people. As was her way, Aloha charmed the Bororos, recording her time and documenting their daily lives. Upon her return, these recordings became *Flight to the Stone Age Bororos*, a film that to this day is an important anthropological resource within the Smithsonian Institute's Human Studies Archive.

In 1932, Captain was murdered on their yacht in California, a crime that remains unsolved. Aloha continued traveling as an explorer, lecturer, and documentary filmmaker, showing women worldwide that it was possible to live a life without borders.

BRAINS, BEAUTY & BREECHES

YIELD: 1 cocktail

Glassware: double Old Fashioned glass

Garnish: freshly grated nutmeg

INGREDIENTS

» 1½ ounces (45 ml) Plantation Original Dark rum

» ½ ounce (15 ml) Amaro CioCiaro

» 3 ounces (90 ml) cold-brewed coffee

» Coconut Whipped Cream (see below)

Coconut Whipped Cream

YIELD: varies

» 3 ounces (90 ml) cold unsweetened coconut milk

» ½ ounce (15 ml) simple syrup

» ½ ounce (15 ml) whipping cream

» scant barspoon vanilla extract

» sugar to taste (optional)

By Micaela Piccolo

Maison Ferrand, Shanghai, China

Creator Micaela Piccolo conceived of this drink "to keep some pep in your step along with some unusual flavor pairings." Rum and coconut whipped cream bring to life the exotic flavors of the lands Wanderwell visited: "If I had a long day of filming and had to keep going like Aloha, I would order this drink in a heartbeat."

DIRECTIONS:

Fill a double Old Fashioned glass with ice. Add rum, Amaro, and coffee, leaving about 1 inch (2.5 cm) at the top of the glass. Top with whipped cream. Garnish with nutmeg and serve.

Coconut Whipped Cream

Place all ingredients in a mixing bowl and whip. Keep cold until ready to use.

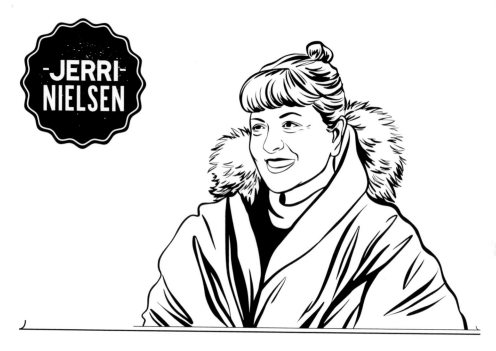

(1952—2009), Doctor
—

Jerri Nielsen's marriage of twenty-four years ended with a bitter divorce in 1998. That same year, she answered an ad in a medical journal seeking a physician to work a year-long stint at the south pole. On November 21, 1998, Nielsen arrived at the two-bed "Hard Truth" Medical Centre, stocked with supplies from the 1950s.

In March, Nielsen discovered a hard truth of her own: a lump developing in her breast. The Arctic winter was in full swing with constant darkness and temperatures 110°F below zero (-79°C); it would be six months before anyone could come or go. Nielsen kept the news to herself, but secretly began to train her colleagues to use the X-ray machine and run IVs, should she die before another doctor could reach them at the South Pole.

When Nielsen finally told her colleagues in June, National Science Foundation officials decided to make a risky and dangerous airdrop of chemotherapy drugs and equipment. A carpenter and a welder helped perform her fine needle biopsy. A computer technician used a 50-year-old microscope and a camcorder to send images of the biopsy to the U.S. A heavy equipment mechanic and a machine operator administered Nielsen's chemo, while the carpenter set up her IVs. Oncologist Kathy D. Miller guided Nielsen through her treatment remotely.

By September, Nielsen was suffering from her chemo very badly. On October 16, she was airlifted back to the U.S., the earliest polar spring extraction in history. She continued treatment at home and went on to live for ten more years, speaking and raising money and awareness for cancer charities. Her bestselling book about the experience, *Ice Bound*, was turned into a TV-movie starring Susan Sarandon in 2003.

Here's to Jerri Nielsen, battling cancer in the highest, driest, coldest, most hostile, and remote place on Earth!

❝ The Arctic winter was in full swing with constant darkness and temperatures 110°F below zero; it would be six months before anyone could come or go.

POLAR PLUNGE

YIELD: 1 cocktail

Glassware: Irish coffee glass or clear mug

Garnish: star anise

INGREDIENTS

» 1½ ounces (45 ml) aged rum

» ½ ounce (15 ml) Yellow Chartreuse

» ¼ lemon or 2 wedges studded with cloves

» 5 ounces (150 ml) turmeric ginger tea

By Lynnette Marrero
Speed Rack, New York, NY

Jerri Nielsen was "resourceful and strong, someone who was clearly tested like a teabag in hot water," says drink creator Lynnette Marrero. Ginger and turmeric are natural homeopathic spices that are used for a variety of medicinal purposes, a flavorful nod to her amazing ability to care for her own health in the most challenging conditions.

DIRECTIONS:

Pour rum and Chartreuse into a mug. Gently express lemon into mug. Add hot tea. Stir and garnish with star anise. Serve.

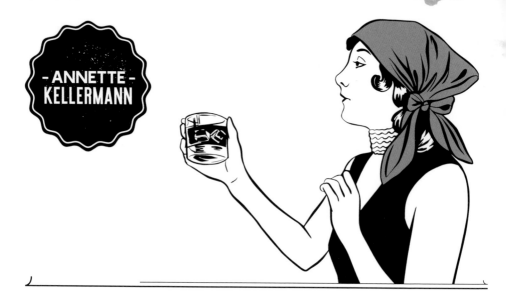

(1886—1975), Athlete
—

It's hard to imagine that a woman nicknamed "Diving Venus" was once a seven-year-old child with rickets who was terrified of the water. Such was the case with athlete and vaudeville star Annette Kellermann. On the advice of doctors, she shed her required steel leg braces and conquered her fear through swim classes. By the age of thirteen, her recovery was almost complete. Her aquaphobia had turned to passion, so she turned her attention to mastering various strokes for competitive swimming.

By 1905, Kellermann held all the world records for women's swimming and set her sight on firsts. In August she became the first woman to attempt to swim the English Channel, a feat that had only been accomplished once thirty years prior. Kellermann's attempts were unsuccessful, but they opened up a previously unknown world of distance swimming for women.

At the age of twenty, Kellerman turned her attention to an art of her own making, vaudeville aquatics. Kellermann combined dance, theater, and high-diving with elaborate costumes and a mythical stage personality to create something truly unique. By 1914, she was the highest paid vaudeville star in the U.S., making $2,500 per week.

Perhaps Kellerman's contribution with the most reach was her promotion of the women's one-piece swimsuit. In the early 1900s, women in the U.S. and across Europe could "bathe" by dipping themselves in water wearing cumbersome get-ups with pantaloons, but they were not allowed to swim. However, by the late 1800s Australian women had begun to wear men's short-legged costumes for competitive swimming. Kellerman adopted the traditionally male garb too, resulting in her arrest at Revere Beach in Massachusetts at a swimming exhibition. News of the arrest spread worldwide, increasing her notoriety. Seizing the opportunity, Kellermann designed a new line of swimwear, liberating women from the unwieldy traditional swimming garb.

Now let's dive into a toast to Annette Kellermann!

VENUS DIVER

YIELD: 1 cocktail

Glassware: Pearl Diver or other shapely or tiki classic

Garnish: pineapple leaves and grapefruit twist

INGREDIENTS

- » 1½ ounces (45 ml) gold Virgin Islands rum
- » ¾ ounce (22 ml) Demerara rum
- » ½ ounce (15 ml) gold Jamaican rum
- » 1 ounce (30 ml) fresh grapefruit juice
- » ¾ ounce (22 ml) fresh lime juice
- » ½ ounce (15 ml) fresh pineapple juice
- » 1 teaspoon (5 ml) falernum
- » dash Angostura bitters
- » ¾ ounce (22 ml) Venus Diver Mix (see below)
- » 6 ounces (¾ cup, 170 g) crushed ice

Venus Diver Mix

YIELD: about 2 ounces (60 ml)

- » 1 ounce (30 ml) coconut oil (or sweet butter)
- » 1 ounce (30 ml) honey
- » 1 teaspoon (5 ml) cinnamon-infused sugar syrup
- » ½ teaspoon vanilla syrup
- » ½ teaspoon pimento liqueur, such as St. Elizabeth's allspice dram

By Erin Mosley

LUPEC Boston founding member, Bon Vivant, Chicago, IL

"When it came to drinking, Annette was ironically dry," says creator Erin Mosley. *"The Venus Diver honors her rich and multifaceted life with a mix of ingredients inspired by her travels."*

DIRECTIONS:

Mix liquid ingredients with an immersion blender. Strain over a fine mesh sieve or cheesecloth over ice.

For the garnish, use a cocktail spear to create something inspired by a mermaid tail out of the pineapple leaves and grapefruit twist. Add a sprinkle of fresh grated cinnamon and allspice on top of drink.

Venus Diver Mix

Cream all ingredients together just before using. Warm slightly if necessary to incorporate coconut oil. Store at room temperature.

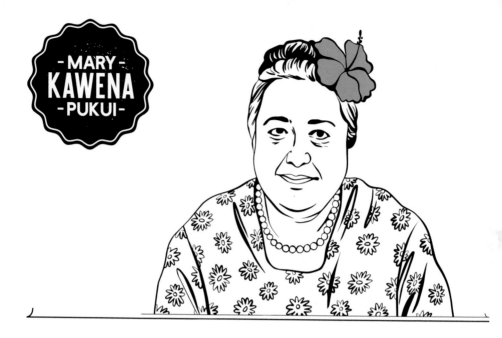

(1895–1986),
Historian/Activist/Preservationist
—

At the time of Mary Kawena Pukui's birth, Hawaii was in a full-blown identity crisis. Foreign businessmen interested in the booming sugar industry had inundated the islands, the proselytizing activities of Christian missionaries had relegated elements of traditional Hawaiian culture to the shadows, and the growing Hollywood film industry was misrepresenting the "exotic" aspects of Polynesian culture. Thankfully in Mary's childhood home, Hawaiian sovereignty was alive and well. Raised bilingually and biculturally, she learned respect and reverence for her family's history through her grandmother, once a dancer in the court of Queen Emma, and her grandfather, a traditional healer.

Pukui started gathering stories, lessons, and lore throughout her teens, further enriching her appreciation for Hawaiian culture. After being punished for speaking with a friend in Hawaiian, Pukui dropped out of high school and began helping her cousin at the Bernice Pauahi Bishop Museum, the Hawaii State Museum of Natural and Cultural History, initiating a career of working with ethnologists, anthropologists, and biologists.

An avid historian with a knack for language and a steel-trap memory, Pukui traveled throughout the islands recording oral histories, songs, and memories. She was revered for her translation abilities and was gifted in rendering not just words but also poetic flair and mood, while providing historical and ethnological background. A prolific writer, Pukui published more than fifty books; she co-authored the most respected Hawaiian dictionary and wrote music and lyrics to more than 150 songs and chants.

From the revival of ancient sailing methods to the traditional art of hula to the use of the Hawaiian language on street signs, one can experience Pukui's legacy throughout Hawaii. It's a legacy deserving of a toast from one of the most influential women in the hospitality industry, Hawaii native Julie Reiner.

Where Rum Comes From

Rum is made using the juice of the sugarcane plant. Some makers use the fresh juice of the plant, which is extracted by pressing the cane stalks, as their raw material, and others use molasses, the by-product of the sugar refining process. It is distilled in either traditional pot stills or continuous column stills. Then it's bottled as silver rum or aged in charred oak barrels that once held whiskey or bourbon anywhere from one to thirty years or more. After aging, the rum can be either bottled at the strength at which it was aged or blended and then bottled.

PINK LAVA

YIELD: 1 cocktail

Glassware: 20-ounce (590 ml) hurricane glass

Garnish: Pineapple leaf and orchid

INGREDIENTS

» 1 ounce (30 ml) Kō Hana Kea Hawaiian Agricole Rum
» 1 ounce (30 ml) Plantation 3 Year rum
» 1½ ounces (45 ml) Guava Syrup (see below)
» ½ ounce (15 ml) lilikoi (passion fruit) puree
» ½ ounce (15 ml) lime juice
» ¼ ounce (8 ml) Campari
» 1½ cups (8 ounces) ice

Guava Syrup

YIELD: Approx 1¾ cups (295 ml)

» 1 cup (235 ml) guava puree
» 1 cup (200 g) sugar

By Julie Reiner
Clover Club, Leyenda, Brooklyn, NY

Created by Hawaii native and cocktail maven Julie Reiner, this drink makes Hawaiian flavors of lilikoi and guava shine alongside Hawaiian rum, to honor the local people and the land. "Mary fought for the preservation of Hawaiian culture, and dedicated her life to making sure that Hawaiian history wasn't lost." A true hero!

DIRECTIONS:

Blend all ingredients except Campari thoroughly with a blender. Pour into a glass and top with Campari. Garnish with a pineapple leaf and orchid. Serve with a straw.

Guava Syrup

Combine ingredients in a saucepan and heat until the sugar melts. Bottle and store in the refrigerator for up to 1 month.

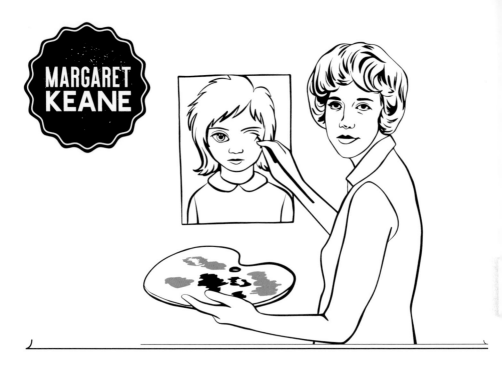

MARGARET KEANE

(1927—), Painter

—

Anyone who lived in the 1960s will most likely remember the works of Margaret Keane featuring wide-eyed waifish children with down trodden expressions. The *Los Angeles Times* described the presence of her work best saying they were easily found anywhere from Walgreen's to Woolworths. Unfortunately, although her work was ubiquitous, the Keane who was benefitting from the work was not the one painting them.

In 1955, Margaret met the charming Walter Keane. There was romance and wedded bliss until Margaret learned that her beloved had been taking responsibility for her paintings. The ruse continued with Margaret painting while Walter took the credit, and the popularity of the images grew. Margaret's paintings became omnipresent, selling in the millions as replications on prints and postcards. Walter celebrated in the success of his scheme, taking advantage of the finest in nightlife, including plenty of women, while keeping Margaret imprisoned in their home.

Ten years into the marriage, Margaret was finally able to obtain a divorce. She moved to Hawaii to start her own gallery and took Walter to court, suing him for the royalties from her work. The case became an extended game of he said/she said until the judge ordered each of them to paint one of the iconic children in the courtroom. Claiming a shoulder injury, Walter was unable to produce while Margaret completed her painting in under an hour. Margaret was awarded $4 million; however, she never saw a cent, because Walter had squandered it away on his excesses.

Margaret continued to paint, the once-sullen children now frolicking in waves with bright eyes and subtle smiles reminding us that it's never too late to reclaim our identity and our happiness.

> **The ruse continued with Margaret painting while Walter took the credit, and the popularity of the images grew.**

IT'S MAI TAI'M

YIELD: 1 cocktail

Glassware: double rocks glass

Garnish: sprig of mint

INGREDIENTS

» 1½ ounces (45 ml) Smith & Cross Jamaican Rum

» ¾ ounce (22 ml) fresh lime juice

» ½ ounce (15 ml) Small Hand Foods Orgeat

» ½ ounce (15 ml) Leopold Bros Aperitivo

» ½ ounce (15 ml) Gifford Banane du Brésil

» pinch salt

» 2 dashes Angostura bitters

By Cecily Kllanxhja

ABV, San Francisco, CA

Conceived by Cecily Kllanxhja, It's Mai Tai'm is bitter and salty to recognize the impropriety of Keane's work being stolen, while also "bright and tropical, showing the hope and strength that she had as she continued her art and reclaimed her name."

DIRECTIONS:

Pour rum, lime juice, orgeat, aperitivo, Banane du Brésil, and salt into a shaker. Cover with crushed ice, shake 3 or 4 times, and pour into glass. Top with crushed ice to fill, add bitters, and garnish with sprig of mint and a straw cut to about 2 inches (5 cm) above the glass.

(1984–), Activist

—

If perseverance were a commodity, Pushpa Basnet would be the wealthiest woman in the world. Using compassion, conviction, and resilience, Basnet is redirecting the futures of a group of Nepalese children who traditionally paid the price for the sins of their parents.

Basnet began her career in social work at the age of twenty-one while studying for her undergraduate degree. On a class trip to a local jail, Basnet was shocked to learn that in the absence of a fitting guardian, parents would be forced to choose between taking their children to jail with them or surrendering the children to an orphanage. Dishertened that a child could be raised without experiencing anything beyond the boundaries of a jail's walls, Pushpa founded the Early Childhood Development Center in 2005. Every day, Pushpa would pick up children to offer them a taste of life outside of incarceration and the incentive to break the all too common generational crime cycle.

In 2012, Basnet was named a CNN Hero, which included a monetary prize. This money, combined with proceeds from Susan Sarandon's documentary about Basnet entitled *Waiting for Mamu*, made it possible for her to realize her dream project. In 2014, the first stone was laid for the Butterfly Home, a residential center for children whose parents are incarcerated. In April 2016, four months short of completion, the first of two massive earthquakes that would destroy 60 percent of the construction hit Nepal, leaving the children sleeping in tents. Undeterred, Basnet began anew the process of fund-raising when the German organization Ein Herz Fuer Kinder stepped in with an offer to fund the rebuild.

Whether through the ECDC, the Butterfly Home, or the multitude of programs she has implemented over the years, Basnet has been adamant that the children she serves maintain close relationships with their parents and has found that parents are frequently encouraged to change their behaviors and lifestyles because of the growth they see in their children. Let's raise a toast to Basnet's example of turning obstacles into opportunities!

It's amazing, I never get tired. (The children) give me the energy.... The smiles of my children keep me motivated.

— P U S H P A B A S N E T

THE CHRYSALIS

YIELD: 1 cocktail

Glassware: coupe glass

Garnish: cucumber round

INGREDIENTS

» 2 ounces (60 ml) Cana Brava rum

» ¾ ounce (22 ml) Tulsi Honey (see below)

» ¾ ounce (22 ml) lime juice

» 5 ounces (150 ml) Tempus Fugit Kina L'Avion D'or

» 2 drops Bitter Truth Cardamom Bitters

» 2 cucumber rounds

Tulsi Honey

YIELD: about 2 cups (470 ml)

» ½ ounce (16 g) Tulsi Holy Basil Tea

» 1 cup (235 ml) good local honey

By Kellie Thorn
Empire State South, Atlanta, GA

The chrysalis stage of a butterfly's life requires a safe place to rest and grow, and that's how creator Kellie Thorn imagined the Butterfly Home to be for the many children served by Basnet. This refreshing concoction also calls upon healing ingredients such as cooling cardamom and cucumber and Tulsi (also called Holy Basil), revered for its medicinal properties and calming effects.

DIRECTIONS:

Muddle cucumbers in a mixing vessel. Add all other ingredients and ice to the vessel and shake. Fine strain into a coupe glass. Garnish with a cucumber round and serve.

Tulsi Honey

Bring 1 cup (235 ml) water to a boil and pour over tea. Allow to steep for 10 minutes. Strain solids, add honey, and stir.

(1906—1982), Spy/CIA Operative

—

Virginia Hall had her sights set on a career in diplomacy, but that all changed while she was hunting marsh birds in Turkey. Hall was on assignment in İzmir when she injured her left leg below the knee so badly, it had to be amputated. The State Department had strict rules against persons with disabilities joining the diplomatic corps, ending her diplomatic career abruptly.

Hall was fitted with a prosthesis she dubbed Cuthbert, a hollow wooden appendage with an aluminum foot weighing 7 pounds (3 kg). She traveled to Paris on the eve of the German invasion to join the French Ambulance Corps, moving to London to work at the U.S. War Department when France fell. Britain had just established the Special Operations Executive to support resistance operations and "set Europe ablaze." Multilingual and knowledgeable about the French countryside, they recognized Hall would be a valuable asset and recruited her as their first female agent.

Disguised as a *New York Post* reporter, Hall established a department in the Haute-Loire region. Code named Geologist-5, her mission was to provide information on economic conditions and political developments in Vichy, France. Hall was a gifted recruiter, building her agent network, code-named Heckler, into an important and centrally located logistical hub supporting almost every British agent sent to France. Head of the Gestapo, Klaus Barbie, "The Butcher of Lyon," was hot on her trail, saying: "I would give anything to get my hands on the limping Canadian bitch."

A Catholic priest turned informant would be the end of the "Limping Lady's" service; he blew her cover in September 1942. Hall escaped over the Pyrenees in November, a treacherous 50-mile (80 km) trek. She reported via wireless transmission that Cuthbert was giving her problems, and the operator replied, "If Cuthbert gives you trouble, eliminate him."

Hall became the only civilian woman to receive a Distinguished Service Cross, though she eschewed the publicity surrounding the honor to keep her cover. After the war, she continued her intelligence work in Italy, and she later joined the CIA, where she rubbed shoulders with Kirsten's own Uncle Bob Kehoe! (See page 158.) She spent fifteen years supporting resistance groups in Iron Curtain countries.

> **Virginia Hall is a true hero of the French Resistance.**
>
> —FRENCH PRESIDENT
> JACQUES CHIRAC

CUTHBERT COCKTAIL

YIELD: 1 cocktail

Glassware: coupe glass

INGREDIENTS

» 1⅓ ounces (40 ml) aged rum

» ⅔ ounce (20 ml) sweet cream

» ⅘ ounce (25 ml) Baked Potato Peel Syrup (see below)

» 2 dashes Angostura bitters

Baked Potato Peel Syrup

YIELD: varies

» peels of 2 pounds (1 kg) potatoes, salted and baked until crispy

» granulated sugar

By Anita Oltuszyk

Flisak '76, Gdańsk, Poland

Cuthbert was Virginia's name for her wooden leg, and the flavors behind this drink hold a sense of place to Warsaw during World War II. Creator Anita Oltuszyk imagined baked potato peel syrup as the cheapest and most flavorful option for a World War II era cocktail.

DIRECTIONS:

Combine all ingredients with ice in a shaker. Shake vigorously. Strain.

Syrup

Place peels in a saucepan, cover with water, and bring to a boil. Let cool, strain, and combine liquid with sugar, 2 parts liquid to 1 part sugar.

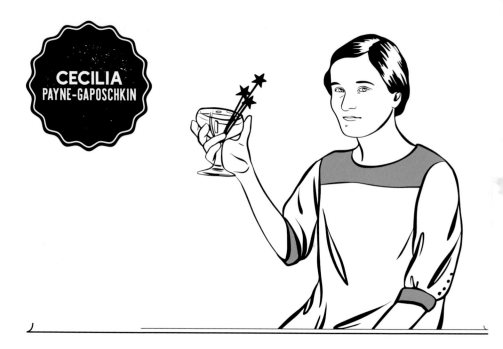

CECILIA PAYNE-GAPOSCHKIN

(1900—1979), Astronomer
—

I n 1919, Cecilia Payne-Gaposchkin knew she
wanted to study science. When she attended a
lecture by astronomer Sir Arthur Eddington about
a trip to the island of Principe, where view of a solar
eclipse proved Einstein's theory of general relativity,
she knew physics was for her. Eddington welcomed
Payne to use the Cambridge Observatory library,
where her interest in astronomy flourished.

Recognizing that her career prospects at
Cambridge would never advance beyond "teacher,"
Payne secured a fellowship at Harvard University.
She relocated to Massachusetts, where she would
become an assistant to the Harvard College
Observatory director Harlow Shapely.

At twenty-five, Payne published her thesis,
"Stellar Atmospheres," which included her contro-
versial discovery that the stars were predominantly
hydrogen and helium. This would later be described
as "the most brilliant Ph.D. thesis ever written in

astronomy" by astronomer Otto Struve. Her work was
reshaped into a book, which was widely acclaimed,
causing astronomers to come around and accept a
theory previously deemed "clearly impossible."

Payne teamed with Russian astronomer
Sergei Gaposchkin, whom she married in 1934
and partnered with on much of her research. She
fulfilled all the duties of a professor, but retained
the title of "technical assistant" for decades, and
was never elected to the elite National Academy of
Sciences like her male colleagues. In 1956, she was
made a full professor, the first female professor in
Harvard University history, as well as chair of the
Astronomy Department.

Cheers to Cecilia Payne-Gaposchkin, who broke
the glass ceiling reaching for the stars!

> There is no joy more intense than that of coming upon a fact that cannot be understood in terms of currently accepted ideas.

— CECILIA PAYNE-GAPOSCHKIN

ELEMENTS OF THE STARS

YIELD: 1 cocktail

Glassware: chilled coupe glass

Garnish: starlight

INGREDIENTS

» 1½ ounces (45 ml) Plantation 3 Star rum

» ½ ounce (15 ml) Cinnamon Syrup (see below)

» ½ ounce (15 ml) lemon juice

» ½ ounce (15 ml) Amaro Montenegro

Cinnamon Syrup

YIELD: varies

» 3½ ounces (100 g) of 3-inch (7.5 cm) cinnamon sticks

» granulated sugar

By Ezra Star

Drink, Boston, MA

Inspired by old world trade, this drink, created by Ezra Star, uses rum as the base, cinnamon and Amaro Montenegro, reminiscent of the spice routes, and bright lemon juice, an allusion to sun and stars. Like Cecilia's theories, the structure is simple but complex in its intent.

DIRECTIONS:

Shake with ice and strain into a chilled coupe glass.

Syrup

Place cinnamon sticks in 1 quart (1 L) filtered water and bring to a boil. Remove from heat and cover until cool. Strain the liquid. Add an equal amount by volume of sugar. Stir to dissolve the sugar. Strain.

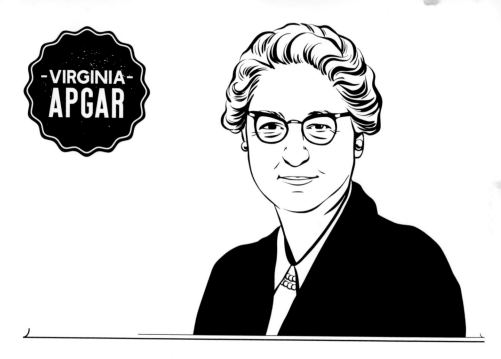

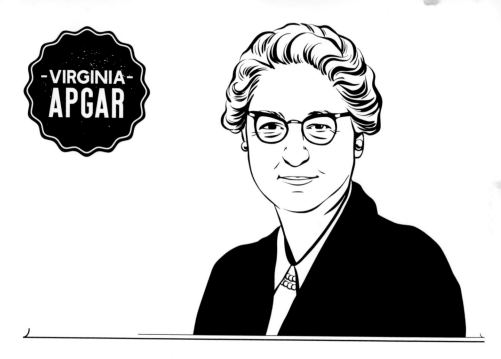

(1909—1974), Doctor
—

Virginia Apgar did poorly in high school home economics and reportedly never did learn how to cook. But she excelled in science and set her sights on medicine. Apgar attended Mount Holyoke, where she was best known for her boundless energy and rapid speech, playing violin in the school orchestra, and majoring in zoology.

Apgar pursued medical training at Columbia University's College of Physicians & Surgeons (P&S) in 1929, one of just nine women in the ninety-person class. After the stock market crashed, her mentor encouraged her to switch fields from surgery to anesthesiology, fearing limited job prospects for her in the Depression economy. Her passion and skills would be perfectly suited to developing the discipline of anesthesiology, which would support advancement in surgery. Apgar rose to the task, which transformed from being mostly handled by nurses and regarded as an inferior specialty to an acknowledged medical

specialty with residency training required. Apgar blazed the trail. She was appointed the first full professor of anesthesiology at P&S in 1949, and the first female professor at the school.

Apgar's academic studies into the effects of anesthesia given during labor on newborn babies led to her most famous contribution to the medical world, the Apgar Score. The score evaluates newborns in the categories of heart rate, respiratory effort, muscle tone, reflex response, and color within one minute of their birth. If you're reading this, you got one: it is still used to predict neonatal survival and neurological development.

Apgar would go on to get a Master's degree in public health, leaving academia in 1959 to devote her life to preventing birth defects through fundraising efforts, education, and work with the organization now known as the March of Dimes.

> **Women are liberated from the time they leave the womb.**
>
> —VIRGINIA APGAR

LAKOTA'S SCORE

YIELD: 1 cocktail

Glassware: 7- to 8-ounce (200 to 240 ml) fizz glass

Garnish: eucalyptus leaf

INGREDIENTS

» 2 ounces (60 ml) white rum

» 1 ounce (30 ml) mandarin orange juice

» ¾ ounce (22 ml) Sichuan Pepper, Eucalyptus, and Basil Syrup (see below)

» ⅔ ounce (20 ml) lemon juice

» dash egg white (approx. ½ egg white)

Sichuan Pepper, Eucalyptus, and Basil Syrup

YIELD: varies

» 7 ounces (200 g) Sichuan peppercorns, lightly toasted

» ⅔ cup (150 ml) fresh eucalyptus leaves

» ½ cup (20 g) fresh basil leaves

» 6⅓ cups (1.3 kg) superfine sugar

By Mary White
The Lobo Plantation, Sydney, Australia

In a nod to Virginia Apgar's pioneering use of anesthesia, creator Mary White used natural anesthetics to build this drink. Sichuan pepper (known for its numbing properties) and eucalyptus (known for its healing properties) are its main flavors. The name is a nod to Hanwi, a divine feminine figure in Lakota mythology, the goddess of the moon, motherhood, family, and femininity.

DIRECTIONS:

Shake ingredients without ice. Add ice and shake. Strain into a fizz glass. Garnish with eucalyptus leaf and serve.

Syrup

Combine all ingredients with 1 quart (1 L) water in a pot over medium heat. Cook about 20 minutes, until strong flavor infuses and sugar has dissolved. Let cool.

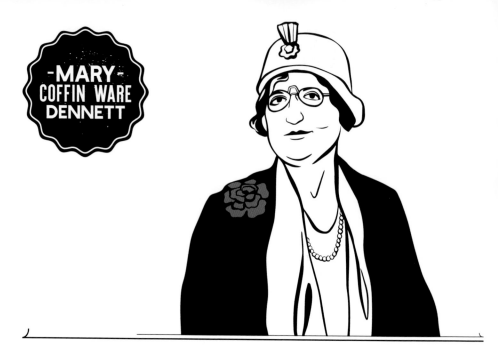

(1872–1947), Social Reformer

—

In 1915, Mary Coffin Ware Dennett was a single mother and a social reformer. In response to her son's questions about sex, Dennett wrote a pamphlet entitled *The Sex Side of Life: An Explanation for Young People*. Her simple solution to an age-old problem was wildly popular and extremely controversial.

Ware married architect William H. Dennett in 1900, but their marriage hit upon hard times. Dennett's second son died a few weeks after a childbirth that left her very ill; her third birth left her even sicker, and she was advised not to become pregnant again by her doctor. Without access to contraception, the couple chose abstinence. By 1909, her husband had started an affair with a family friend. The situation worsening, Mary filed for divorce and custody of her young sons in 1912.

Dennett took up the mantle of sex education as a cause, seeking legislative change. Her 1915 pamphlet provided a realistic and accurate description of intercourse, something absent in other texts, because obscenity laws such as the Comstock Act limited detailed sex education. That year Dennett helped established the National Birth Control League, which lobbied against the Comstock Act.

A 1928 scandal organized by the U.S. Postal Service would be Dennett's greatest challenge to the Comstock Act. The Postal Service fabricated a fake plaintiff who sued Dennett for delivering her a copy of her "obscene" pamphlet. Dennett was convicted in 1929. When the court learned the identity of the plaintiff was fake, Dennett countersued and the verdict was swiftly overturned, because her pamphlet was mailed with educational intent. The trial was highly publicized and led to two more books by Dennett, *Who's Obscene?*, her account of the trial, and *The Sex Education of Children: A Book for Parents*.

In reading several dozen books on sex matters for the young with a view to selecting the best for my own children, I found none that I was willing to put into their hands.

—MARY COFFIN WARE DENNETT

SEX SIDE

YIELD: 1 cocktail

Glassware: coupe glass

Garnish: cucumber ribbon

INGREDIENTS

» 3 cucumber slices

» 5 to 7 Thai basil leaves

» 1 ounce (30 ml) Privateer Silver rum

» 1 ounce (30 ml) Bushido sake

» ¾ ounce (22 ml) lemon juice

» ¾ ounce (22 ml) simple syrup

» pinch salt

Cucumber Ribbon

YIELD: varies

» 1 cucumber

By Andrea Pentabona

The Independent, Somerville, MA

Creator Andrea Pentabona used the Southside cocktail as her inspiration for the Sex Side, dressing up the classic with sake and Thai basil for a tart, sweet, more aromatic expression of the drink.

DIRECTIONS:

Lightly muddle cucumber and Thai basil in a shaker until cucumbers are slightly broken and basil is bruised but not torn. Add all other ingredients to shaker and shake with ice. Strain into a coupe glass. Garnish with cucumber ribbon and serve.

Cucumber Ribbon

Peel a cucumber the long way with a vegetable peeler for a thin piece that is almost translucent. Fold it back and forth to create a ribbon effect. Hold it in place with a bamboo skewer. Balance the skewer on the rim of the glass.

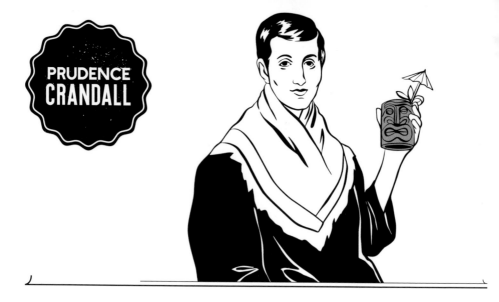

PRUDENCE CRANDALL

(1803–1890), Educator/Activist

—

More than a century before *Brown* v. *Board of Education of Topeka*, Sarah Harris and Prudence Crandall sought to bring education to young black American women.

Prudence Crandall was born into a Quaker family in Hopkinton, Rhode Island, and because Quakers believed in equal educational opportunity, she was educated in Latin, mathematics, and science. At seventeen, she moved to Connecticut to open a private school for girls, which rivaled the local school for boys in its rigor.

In 1832, Crandall admitted a young African-American woman, Sarah Harris, who wanted to become a schoolteacher. Immediate controversy ensued, with white parents calling for Harris's removal. When they then began to withdraw their children, Crandall stopped teaching white girls altogether.

In 1833, Crandall opened a school dedicated to the education of young black women. She recruited middle-class girls to enroll in her boarding school and teacher training program of which abolitionist William Lloyd Garrison was a supporter. Courses included reading, writing, arithmetic, grammar, geography, history, philosophy, chemistry, astronomy, painting, music, piano, and French.

With residents in an uproar, the state eventually passed the "Black Law," which forbade the education of any students of color who were not inhabitants of the state of Connecticut without the local town's permission. Crandall was arrested, jailed for a night, and faced three trials for her transgressions. She continued to operate as she awaited trial despite threats of violence. The school's drinking water well was even poisoned, but Crandall and her students persevered.

An appeal before the Supreme Court eventually overturned an earlier conviction, and arguments from her trial were used to support *Brown* v. *Board of Education* a century later. Continued vandalism and an eventual mob assault forced Crandall to close the school. She moved to Illinois with her husband and continued to work as an educator and for social reform.

RUM PUNCH

YIELD: 1 cocktail

Glassware: tiki glass

Garnish: apple and pineapple on a skewer dipped in cinnamon and sugar

INGREDIENTS

» 2 ounces (60 ml) Havana Club 3 Year Old Rum

» 1 ounce (30 ml) Captain Morgan Spiced Rum

» 2 ounces (60 ml) Tropical Mix (see below)

» 2 ounces (60 ml) pineapple juice

» 1 ounce (30 ml) Ginger Syrup (see below)

Ginger Syrup

YIELD: about 1 cup (235 ml)

» 2 cups (400 g) sugar

» 1 cup (235 ml) water

» 1 cup (100 g) peeled, sliced ginger

Tropical Mix

YIELD: 1 quart (1 liter)

» 5 ounces (150 g) fresh apple

» 12 ounces (350 g) fresh pineapple

» 5 ounces (150 g) fresh mango

» 3 ounces (90 g) passion fruit

By Patience Laryea

Burger and Relish, Osu, Accra, Ghana

Creator Patience Laryea developed a cocktail that could be a study in tiki, quite fitting for a bartender who also dreams of opening a school to help train female bartenders. This complex mix of juices, syrups, and spirits makes for a juicy, exotic drink.

DIRECTIONS:

Mix all ingredients in a shaker, add ice, and shake vigorously for 30 seconds. Strain into a tiki glass filled halfway with ice. Garnish with fresh apple and pineapple dipped in cinnamon and sugar and serve.

Syrup

Bring sugar, water, and ginger to a simmer, stirring until sugar is dissolved. Simmer for 30 minutes, let cool, and strain.

Tropical Mix

Combine all ingredients and juice.

(1971–), Musician

—

When *Baduizm* dropped in 1997, it caused a sensation, selling nearly 3 million copies, winning two Grammys, and cementing Erykah Badu as the Queen of Neo-Soul. "I thought I was ahead of my time. There was nothing like what I was doing—and they agreed, the music business."

Badu was born Erica White in Dallas. She was raised mostly by her mother, Kolleen Wright, her godmother, and two grandmothers: five mothers "if you count Mother Nature." She started acting and dancing as a little girl and enrolled in Booker T. Washington performing-arts school for high school. She changed her name to Erykah Badu, *kah* being Kemetic (Egyptian) for a human's vital energy or "inner-self" and *Ba-du* after her favorite jazz scat-sound.

During college Badu collaborated with her cousin, a music production student, who sent her beats to rap over, one of which inspired her to sing, and their

sound was born. Opportunity knocked in the form of a tour opening for D'Angelo, and Badu took her place in the budding neo-soul scene.

Badu considers herself a touring artist and has been on the road much of the past twenty years. She has three children and considers herself "a mother first." She is a reiki master, a holistic health practitioner, and a doula who incorporates spirituality into her work using tuning forks, crystal singing bowls, and gemstones, hoping to cultivate healing energy through music. Her non-profit B.L.I.N.D. (Beautiful Love Incorporated Nonprofit Development) supports music, dance, theater, and visual arts in underprivileged communities.

Quoting lyrics from her 2008 single "Master Teacher," Badu started the hashtag #staywoke, which became aligned with the Black Lives Matter movement in 2014.

Cheers to you, Badu!

Peace and blessings manifest with every lesson learned. If your knowledge were your wealth then it would be well-earned.

—ERYKAH BADU, "ON AND ON"

BADUIZM

YIELD: 1 cocktail

Glassware: highball glass

INGREDIENTS

» 1½ ounces (45 ml) Old Monk rum

» ½ ounce (15 ml) allspice dram

» 1 ounce (30 ml) condensed milk

» 1½ ounces (45 ml) Thai tea

By Emma Hollander

Trina's Starlight Lounge, Boston, MA

Creator Emma Hollander took inspiration from India, Old Monk's land of origin, and Thailand, including ingredients in a traditional Thai Iced Tea. This bold, spicy, sweet cocktail seems a fitting tribute to Erykah Badu, "one of the most fierce and influential women in the hip hop/soul industry."

DIRECTIONS:

Shake all ingredients with ice. Strain over fresh ice into highball glass and serve.

04

CHAPTER

AGAVE

Ah agave! Spirits that are dear to our hearts!

The early years of our agave drinking were relegated to industrially produced tequila, partially due to price point (thanks college!), partially due to ignorance, and largely due to lack of quality choices. But agave has had a renaissance, and we couldn't be happier. Tequila has reclaimed her roots with wonderful new entrants in the category harkening back to the traditional processes of the nineteenth century. And tequila's predecessor mezcal has crossed the border, bringing hundreds of uninterrupted years of culture and tradition as well as bold flavors to our glass making everything from our margarita to our Old Fashioned variants more exciting.

(1930—), Activist

—

Dolores Huerta is powerfully dedicated to social justice. Her dedication grows out of the kindness and compassion she learned from her mother, Alicia. A single mother, Alicia toiled and saved to purchase a seventy-room motel in the largely agricultural area of Stockton, California. Alicia recognized the financial challenges faced by her boarders, many of whom were recent immigrants, and would slide her scale accordingly, even if that meant not charging her boarders at all.

Huerta started teaching after college and developed an interest in issues of economic inequality when her students arrived to school hungry and shoeless. She met activist Cesar Chavez in 1955 while working for the Stockton Community Service Organization, and they quickly recognized that they shared an interest in organizing farm workers. In 1963, they founded the National Farm Workers Association, the precursor to the powerful United Farm Workers Union formed three years later. Huerta recognized

that this needed to be a movement of families, because often children were employed in the fields alongside their parents. For this reason, nonviolence was a key value of the movement from its outset.

Neither the NFWA nor the UFW had a lot of money, but what the nascent organizations lacked in finances they made up for in Huerta's skills in lobbying, organizing, and negotiation. Huerta was instrumental in organizing the grape boycotts of the late 1960s, including the strike of more than 5,000 grape workers in 1965 that resulted in an historic agreement in the grape industry to increase wages and improve working conditions.

Huerta is also a vocal advocate for women's rights, challenging discrimination within the farm workers movement and beyond. "We, as women, we have to put lights around our accomplishments and around our ideas and not feel egotistical when we do that." *¡Sí se puede!*

> What I'd like to share with people is that what we have to give to our children are values, not so much material, [but] a social conscience. You have to involve them at a very young age so they grow up knowing that this is something they can do that they have power to help people.

— DOLORES HUERTA

¡Sí Le Puede!

YIELD: 1 cocktail

Glassware: chilled coupe glass

Garnish: edible white flower

INGREDIENTS

- » 2 ounces (60 ml) mezcal espadin
- » ½ ounce (15 ml) extra dry vermouth
- » ¼ ounce (8 ml) orange blossom water
- » ¼ ounce (8 ml) Kina L'Aero d'Or

By Victoria Elizabeth Wiley
Agavero, Oaxaca City, Mexico

"Keep it as clean and pure as possible in elegance and strength of Spirit," says drink creator Victoria Elizabeth Wiley. This is a light, floral, spirit-forward cocktail that would delight as an aperitif.*

DIRECTIONS:

Stir ingredients with ice in a mixing glass. Strain into a chilled coupe glass. Garnish with a white flower and serve.

(1935—1997), Athlete

—

Joanie Weston was a natural athlete, proficient at seemingly every sport she tried. A true slugger, Joan once hit eight home runs in a softball game at Catholic Mount St. Mary's College (not wanting to embarrass the opposing team further, the nuns threatened to excommunicate her if she hit a ninth.) But Joan came up in a time when professional sports were the province of men.

Joan was born in 1935, the same year that the concept for roller derby was imagined. Two years later in Miami, writer Damon Runyon devised the rough and tumble rules: skating on a flat, oval track, two teams field up to five players with four blockers and one jammer, who starts the race behind the pack and receives points for lapping members of the opposing team to sprint ahead: a no holds barred, full contact sport.

Joan was born in Huntington Beach, California, and raised in the area by her grandparents. She wasn't Catholic but attended Mount St. Mary's, shocking her grandmother when she decided to become a nun. Joan turned her attention to sports to appease her grandmother, and the first time she laced up her skates for a roller derby tryout, she was hooked.

Joan made her name on the San Francisco Bay Bombers; she was known to her fans as the Blonde Bomber, Blonde Amazon, and Golden Girl. She played for nineteen seasons and was a prime attraction. She was as famous in the 1960s as Peggy Fleming and Billie Jean King, just among a different crowd: instead of wearing tennis whites or figure skates, she raced around a track at 30 miles per hour (48 km per hour), kicking ass.

Joan continued to train skaters and skate in exhibitions until the year before she passed away due to Creutzfeldt-Jakob disease, a rare brain disorder.

About Agave

Turning the succulent wonder that is agave into a spirit we want to sip on takes a lot of work. The plant can take anywhere from six to thirty-five years to reach maturity, and it can weigh between twenty and 1,000 pounds (9 to 455 kg), depending upon the type of agave. Once mature, the plant is harvested by removing the pencas (or fronds) from the piña (heart) using machetes, axes, or coas, specially designed, long-handled, extremely sharp hoes. The piña is then cooked to convert the carbohydrates of the plant into fermentable sugars, after which the plant can be crushed to extract juices from the fibers, fermented, and finally distilled.

YIELD: 1 cocktail

Glassware: 5½ ounce (160 ml) coupe glass

Garnish: long orange twist

INGREDIENTS

» 2 ounces (60 ml) blanco tequila

» ¾ ounce (22 ml) fino sherry

» ½ ounce (15 ml) prickly pear liqueur

» 2 dashes orange blossom water

» 3 dashes Peychaud's bitters

By Sabrina Kershaw
Deep Ellum and Lone Star Taco Bar, Boston, MA

This spirit-forward cocktail created by Sabrina Kershaw is both floral and powerful, with a bold and beautiful color, much like its powerhouse inspiration.

DIRECTIONS:

Stir all ingredients together and strain into a coupe glass. Expel orange zest over the drink and lay over the glass to garnish. Serve.

(1987–), Activist

—

Wai Wai Nu was arrested when she was just an eighteen-year-old law student in Myanmar (formerly Burma.) Wai Wai and her family are Rohingya, a mostly stateless Muslim minority that has been persecuted for decades under an oppressive military dictatorship. Wai Wai's father was a member of Parliament for the political opposition party, and eventually his entire family would be arrested. They were tried with no legal representation. Her father was sentenced to forty-seven years in prison; the rest of the family were sentenced to seventeen years each.

Wai Wai calls her time at the notorious Insein Prison her University of Life, as these were the years she should have spent in college. She was galvanized to activism by her time among fellow prisoners, many of whom were her age, who fell into drugs or the sex trade because of economic destitution and systematic oppression. Wai Wai was released in 2012 when the new government in power embarked on reform, and was greeted with increasing anti-Rohingya violence.

Amnesty International says the Rohingya are among the most persecuted people on the planet.

Wai Wai completed her law degree and has formed two non-governmental organizations dedicated to peace and women's rights. The Women's Peace Network Arakan works as a platform to build peace and understanding between Myanmar's different ethnicities and to advocate for the rights of marginalized women. In 2015, her popular social media campaign encouraged online users to snap a selfie with friends of different ethnic and religious backgrounds and share with the #myfriend hashtag. Wai Wai also co-founded Justice for Women, an organization of female lawyers who provide legal consultation and education for the women of Burma. The group organizes workshops to educate women on negotiating common problems they face in Myanmar, such as sexual harassment and domestic violence.

Cheers to Wai Wai Nu, and her future of activism!

WAI WAI'S WINGS

YIELD: 1 cocktail

Glassware: 5½ ounce (160 ml) coupe glass

Garnish: orange swath

INGREDIENTS

» 2 ounces (60 ml) mezcal

» 1 ounce (30 ml) Mariposa liqueur

» 1 ounce (30 ml) Plum, Pear, and Thyme Shrub (see below)

» ½ ounce (15 ml) lemon juice

Plum, Pear, and Thyme Shrub

YIELD: about 3 cups (700 ml)

» 2 cups (475 ml) apple cider vinegar

» 2 cups (400 g) turbinado sugar

» 3 plums, chopped and de-pitted

» 2 pears, chopped and de-seeded

» 8 sprigs of thyme

By Jess Knight
Boston Harbor Distillery, Boston, MA

Creator Jess Knight's cocktail honors Wai Wai from spirit base to glass: Jess chose the heartiest agave, espadin, mariposa (Spanish for "butterfly") liqueur, a nod to the "tiny prison" in which caterpillars sprout their glorious wings, plums to honor Wai Wai's strength and perseverance, pears to toast her grit and in homage to "the sacred goddess Isis, protector of the dead, 'magical healer,' and mother," and thyme to invoke her courage. The curved glass is like a hand holding the cocktail, "supporting the drink with strength and beauty."

DIRECTIONS:

Shake ingredients with ice and strain. Garnish with orange swath and serve.

Shrub

Bring apple cider vinegar to a boil in a pot over high heat. Reduce heat to simmer. Add sugar and stir until dissolved. Add plums and pears and bring mixture to a low boil, stirring to avoid burning, for 15 minutes. Remove from heat and add thyme. Cool and strain through cheesecloth. Store refrigerated for up to 5 months.

KRISTIN BECK

(1966—), Former Navy SEAL/Activist

—

R etired Navy SEAL Kristin Beck made headlines when she came out as a trans woman in 2013. "My body armor I wear now is a very pretty dress and some heels. It's kind of funny how that changes," Beck told CNN.

Named Christopher Beck at birth, she grew up on a farm in western Pennsylvania and remembers being attracted to feminine clothes and toys as young as age five but was encouraged to pursue more masculine roles by her parents. Before transitioning, Beck married and has two sons from her first marriage.

Beck attended the Virginia Military Institute from 1984 to 1987. She joined the special forces as a Navy SEAL, to be the "toughest of the tough." In her twenty-year-long military career, Beck deployed thirteen times, fought in four wars, fought pirates in the Horn of Africa, and donned a long beard and Pashtun garb to blend in with the mujahideen. Beck is a decorated sailor who has received a Bronze Star, a Purple Heart, and a Meritorious Service Medal, among fifty other ribbons and medals. She was part of the prestigious SEAL Team Six.

The media swarmed after Beck came out in 2013, and her fascinating story was covered in a CNN special with Anderson Cooper and a 90-minute film, *Lady Valor*. She coauthored a book about her experiences called *Warrior Princess*, published in 2013. Beck ran for congress in Maryland in 2016, coming in second in the 5th district's primary. As a civil rights activist, she continues her "new mission," fighting for equality for all Americans.

Transgender doesn't matter. Do your service. Being transgender doesn't affect anyone else. We are liberty's light. If you can't defend that for everyone that's an American citizen, that's not right.

—KRISTIN BECK

NIÑA BRAVA

YIELD: 1 cocktail

Glassware: 4-ounce (120 ml) Nick & Nora glass

Garnish: Grapefruit twist

INGREDIENTS

» 1¼ ounces (38 ml) Del Maguey Vida mezcal

» ¾ ounce (22 ml) Cynar

» ¾ ounce (22 ml) Dolin dry vermouth

» ¼ ounce (8 ml) St-Germain

By Melissa "Mellie" Wiersma

Covina, Roof at Park South, Jupiter Disco, New York, NY

Mellie Wiersma created a drink that balances smoky mezcal and bitter Cynar with St-Germain and a light, elegant vermouth.

DIRECTIONS:

Stir all ingredients. Twist grapefruit zest over drink and discard. Serve.

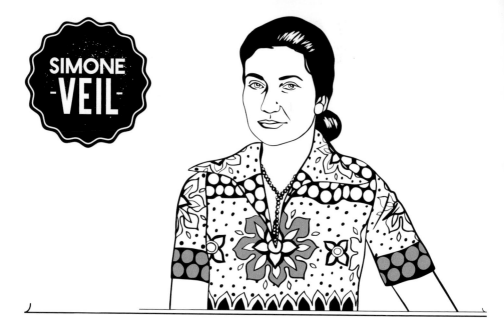

SIMONE -VEIL-

(1927—2017), Politician
—

Simone Veil completed her baccalaureate just one day before she was sent to Auschwitz: "I found myself thrown into a universe of death, humiliation, and barbarism," she wrote. "I am still haunted by the images, the odors, the screams, the humiliation, the blows, and the sky, ashen with the smoke from the crematoriums." She and her sisters would survive the concentration camps; her mother died, and her father and brother were deported and never seen again.

Veil was a figure at the center of French political life for more than forty years. She was trained in law and political science and passed the extremely challenging exam to become a magistrate, a position with which she advanced her career while raising a family. In 1974, President Valéry Giscard d'Estaing visited her home to consider her husband for an appointment in government, but after meeting Simone, selected her for a position instead. She was the second woman to hold full cabinet rank, Minister of Health, in France.

In 1974, Veil championed a law legalizing abortion, still known as the Veil law, "a cornerstone of women's rights and secularism in France." It was controversial and hotly debated, with Veil bearing the brunt of vicious insults from protesters who likened abortion to Nazi euthanasia. It passed in 1975.

Veil championed European Unity and was the first president of the elected European Parliament, from 1979 to 1982. She remained a member of the European Parliament until 1993.

Veil was remembered as the conscience of France when she died in 2017. She is laid to rest honorably in the Pantheon in Paris, alongside Voltaire, Victor Hugo, Marie Curie, and France's finest. "Her uncompromising humanism, wrought by the horror of the camps, made her the constant ally of the weakest," remembered President Emmanuel Macron, "and the resolute enemy of any political compromise with the extreme right."

> I will share a conviction of women, and I apologize for doing it in front of this assembly comprised almost exclusively of men: No woman resorts to abortion lightheartedly.

—SIMONE VEIL

LA LOI VEIL

YIELD: 1 cocktail

Glassware: coupe glass

INGREDIENTS

» 1 ounce (30 ml) blanco tequila

» 1 ounce (30 ml) Don Ciccio & Figli fennel liqueur

» 1 ounce (30 ml) fresh grapefruit juice

» ¼ ounce (8 ml) fresh lime juice

» ¼ ounce (8 ml) simple syrup

» spritz cardamom bitters

By Caitlin Sullivan

Lone Star Taco Bar, Boston, MA

Caitlin Sullivan's toast combines classically delicious tequila and grapefruit with herbaceous fennel and cardamom bitters for a drink that is tart and slightly savory, assertive like its namesake.

DIRECTIONS:

Shake ingredients except bitters with ice in a mixing glass. Spritz a coupe glass with bitters and strain cocktail into glass. Serve.

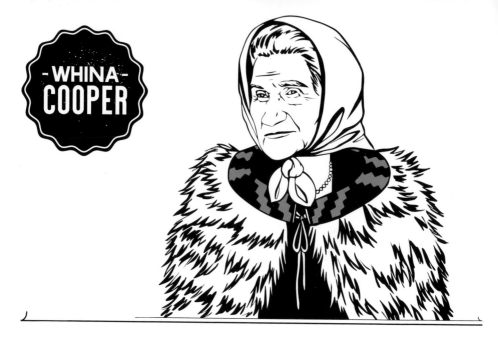

(1895–1994), Activist
—

W hina Cooper was an extraordinary and controversial pan-tribal leader of the Māori in New Zealand. She made waves by defying Māori customs from a young age, upsetting birth order and paternalism traditions by overshadowing her brothers as her father's favorite, and speaking out against a European farmer seeking to claim Māori mudflats on the marae, a tribal meeting space traditionally reserved for men.

Born Josephine Te Karaka, Whina led her first political protest against the aforementioned farmer at just eighteen years old. While her father, a tribal leader, sought to block his move onto Māori land legislatively, Whina organized a group of peers to follow behind the farmers seeking to drain the swamp, filling in the land just as quickly as it could be excavated.

Whina was elected foundation president at the inaugural conference of the Māori Women's Welfare League in September 1951. She focused on better

health care and increased involvement for women in the native rights movement. She actively created regional branches. The League boasted more than 300 branches and 4,000 members by the mid-1950s, and was influential in improving conditions for Māori facing discrimination in housing and employment.

In 1975, at the age of eighty, Whina Cooper led a 620-mile (1,000 km) march from Te Hapua to Wellington to show the Māori dedication to retaining land and culture. The march started with fifty-four people in Te Hapua, but as they marched through towns their numbers grew. They arrived at Parliament 5,000 marchers strong to deliver a memorial of rights from more than 200 Māori elders and a petition of 60,000 signatures to protest the ongoing land alienation: a potent symbol of the Māori cultural renaissance to come.

LA DOÑA

YIELD: 1 cocktail

Glassware: 5-ounce (150 ml) Nick & Nora glass

Garnish: orange twist

INGREDIENTS

» 1½ ounces (45 ml) Tequila Tromba Reposado

» ½ ounce (15 ml) Cherry Heering Liqueur

» ¾ ounce (22 ml) Aperol

» 2 dashes Angostura bitters

By Alex Ross
Melbourne, Australia

Alex Ross named her strong, stirred, spirit-forward drink La Doña, which is feminine for "the boss" in Spanish: "I think that kind of speaks for itself. Boss women are inspirational."

DIRECTIONS:

Stir all ingredients with ice and strain. Garnish with an orange twist and serve.

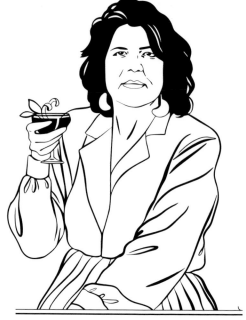

(1945—2010), Politician

—

Wilma Mankiller's grandfather was among 16,000 Native Americans forced to vacate their ancestral homes in the 1830s at Andrew Jackson's behest. The Cherokee people traveled 1,000 miles (1,600 km) at bayonet-point along the Trail of Tears to newly designated Indian Country in Oklahoma. His granddaughter would make history 150 years later as the first female principal chief of the Cherokee Nation.

Wilma grew up on a 160-acre (0.25 sq km) land tract in Tahlequah, Oklahoma, called Mankiller Flats. Her father was full Cherokee, her mother of Dutch and Irish descent; the family name "Mankiller" denoted tribal military rank. Wilma never felt poor growing up, though they lived in a house without electricity or indoor plumbing.

As part of a 1956 Bureau of Indian Affairs relocation program, the Mankillers moved to California with the promise of jobs and a better life; Wilma remembers it as "her own little trail of tears." This situated Wilma right in the heart of the Bay Area as the Civil Rights Movement dawned. She was inspired to activism in 1969, when a group of young Native Americans occupied Alcatraz Island to draw attention to the mistreatment of Native Americans by the government. They were there for nineteen months, and Wilma visited and helped fundraise for the cause.

After divorcing her first husband, Wilma returned to Mankiller Flats in 1977 with her children. She founded the Community Development Department for the Cherokee Nation, which made great strides in community water systems and housing. Principal Chief Ross Swimmer invited Wilma to be his running mate in 1983, and she took his seat when he joined the Bureau of Indian Affairs, becoming the first female principal chief in 1985. Wilma was re-elected in 1987 and in 1991, with 83 percent of the vote.

Mankiller stepped down from her role in 1995 due to health problems, and in 1998 she was awarded a Presidential Medal of Freedom by President Bill Clinton.

Mezcal: The True Grandmother of Agave Distillates

Some mezcal producers can trace the lineage of their distillate and the process they are using back hundreds of years. The ancient knowledge is passed down generationally, preserving a rich history and culture. Mezcal is made in nine different states in Mexico and allows for the use of more than twenty different types of agave, each resulting in different flavors. To many, the quality most associated with mezcal is smokiness. This characteristic is a result of the traditional process of roasting the agave in the earth over stones that have been heated by a hardwood fire. Elements of the roast should be present, but in a mezcal made by a talented hand, this smokiness will be well balanced with the other robust flavors. Although many *palenqueros* (mezcal producers) use copper stills, clay, stainless steel, wood, or a combination of the above often come into play as well. From the location of the *palenque* to the varieties of agave used to the wood used in the roast, the choices a *palenquero* makes all result in different flavors, making mezcal one of the most diverse spirit categories in the world.

THE MANKILLER

YIELD: 1 cocktail

Glassware: coupe glass

Garnish: orange peel and chamomile

INGREDIENTS

» 1 ounce (30 ml) Del Maguey Vida mezcal

» 1 ounce (30 ml) Lustau Manzanilla sherry

» ½ ounce (15 ml) Bigallet China-China

» ¼ ounce (8 ml) Averna

» ¼ ounce (8 ml) Luxardo Aperitivo

» 2 dashes Angostura bitter

By Annemarie Sagoi

Occidental, Williams & Graham, Denver, CO

This spirit-forward cocktail created by Annemarie Sagoi balances three types of bitters with smoky mezcal and the salinity of Manzanilla sherry. This drink is powerful and assertive with a bright floral nose.

DIRECTIONS:

Stir ingredients with ice in a mixing glass and strain. Garnish with orange peel and chamomile and serve.

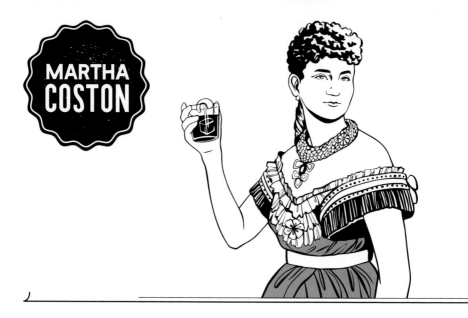

MARTHA COSTON

(1826—1904), Inventor

—

If single motherhood is a challenge today, one can only imagine the hardship in antebellum America. At age sixteen, Martha Coston hitched her wagon to the star of Boston-based scientist Benjamin Franklin Coston. He was just nineteen years old, but he was a promising inventor who headed the pyrotechnic laboratory of the U.S. Navy.

The Costons had a young family of four children when Benjamin died in 1848, most likely poisoned by the hazardous chemicals of his trade. Martha was penniless. What Martha did know was that her husband had been working on a revolutionary new signaling system, a wand displaying three colors on a rotating rod, to be used at night. She shared the prototype with the U.S. Navy and, assured that this was a viable project, set to work.

Her brilliant husband didn't leave much in the way of notes, so Martha set herself to the task of reverse engineering the tool, basically from scratch. She immersed herself in his notebooks, employing chemists and pyrotechnicians in the process. She

would later write in her memoirs: "The men I employed and dismissed, the experiments I made myself, the frauds that were practiced upon me, almost disheartened me; but . . . I treasured up each little step that was made in the right direction." Little has changed from the formula Martha settled upon; it's the one used for highway flares today.

In February 1859, a Navy board issued a report regarding what would become the Coston flare, determining it a better signal than any known to them. Over the course of the Civil War, the Union Navy purchased one million flares from Martha Coston's company, with immediate success. A commander-in-chief could communicate with distant vessels without error. Thousands of signals kept the chain of command going, night after night. And they were also an easy indication of who might be the enemy.

Cheers to the luminous legacy of Martha Coston!

The frauds that were practiced upon me almost disheartened me; but...I treasured up each little step that was made in the right direction.

—MARTHA COSTON

MODERN LOVE

YIELD: 1 cocktail

Glassware: double Old Fashioned glass

Garnish: salt and grapefruit peel

INGREDIENTS

» 2 ounces (60 ml) reposado tequila

» ¾ ounce (22 ml) Campari

» ¾ ounce (22 ml) Giffard Pamplemousse Rose

» 1 pinch Himalayan sea salt

By Jane Fishel
Andaz Hotel, Savannah, GA

Campari and Pamplemousse Rose give this strong stirred cocktail a gorgeous bright red hue, luminescent like Coston's famous flares.

DIRECTIONS:

Stir ingredients with ice in a mixing glass and strain. Flame the grapefruit peel into the drink, rub the peel on the side of the glass, and discard. Add one large ice cube and a pinch of salt on top of the cube. Serve.

(1878—1968), Scientist

—

At first blush, the phrase "behind every successful man is a great woman" has its charms. Utter it about Lise Meitner, however, and you will feel the wrath of our side-eye.

Lise was born in 1878 into an intellectual Jewish family. Her father believed his daughter should receive the same education as his sons. She became the second woman to obtain a doctoral degree in physics at the University of Vienna, at a time when women weren't allowed to attend institutions of higher education (she had a private tutor).

Meitner moved to Berlin and was introduced to Max Planck, whose lectures were for men only. He made an exception for Meitner, and after a year she became his assistant, starting a long working relationship with chemist Otto Hahn. In 1912, the Meitner-Hahn team moved to the Kaiser-Wihelm Institute (KWI), where Lise worked as a "guest" in Hahn's Department of Radiochemistry for a full year before being awarded a full term position (an equivalent job to Hahn's with substantially less pay). Lise became the first professor of physics at the University of Berlin in 1926.

Once Hitler came to power, it was a matter of time before Lise needed to flee. She escaped, landing in the Stockholm lab of Manne Siegbahn, who wouldn't let women work there because "they would catch their hair on fire." Meitner did her work in the basement.

Lise continued to correspond with Hahn, meeting secretly and performing experiments—hers in Stockholm, Hahn's in Berlin—that would lead to the co-discovery of nuclear fission. Hahn published his work in 1939, with no credit to Meitner. He also failed to mention her in 1944, while receiving a Nobel Prize in Chemistry for the work.

Meitner was written out of the discovery of fission, but she remained on the right side of history. Her colleagues in Germany, in their pursuit of science, collaborated with and supported the Nazi regime, but when Meitner was asked to join the American Manhattan Project, she flatly refused: "I will have nothing to do with the bomb." She was named "Woman of the Year" in 1946 by the National Press Club. And in 1997, element 109 was named meitnerium in her honor.

> Life need not be easy, provided only that it is not empty.

—LISE MEITNER

WILDBERRY GLORY

YIELD: 1 cocktail

Glassware: 5½–ounce (160 ml) Nick & Nora glass

Garnish: half strawberry

INGREDIENTS

» 1 ounce (30 ml) Del Maguey Crema de Mezcal

» ½ ounce (15 ml) Monkey 47 Gin

» ¼ ounce (8 ml) Giffard Fraise de Bois

» ¾ ounce (22 ml) Lustau Vermut

» ½ ounce (15 ml) Kina L'Avion d'Or

By Karen Fu

Studio Restaurant & Bar, Freehand Hotel, New York, NY

Creator Karen Fu's cocktail combines wild strawberry liqueur, aperitif wines, and a double base of gin and mezcal for a drink that is a strong and spirit-forward nod to its inspirational broad.

DIRECTIONS:

Stir ingredients with ice in a shaker and strain. Garnish with half a strawberry and serve.

NO +
PEDERASTAS
NO +
CORRUPCION

(1963—), Journalist/Activist
—

"**I** don't scare easily," says Lydia Cacho Ribeiro, and a quick scan of her work as a journalist attests to this. For twenty years, she has been uncovering complex networks of human trafficking and violence against women while implicating some of the most powerful men in her country in the process.

Cacho Ribeiro attributes her feminism to the examples set for her by her grandmother, who protected activists under the dictatorships of Oliveira Salazar in Portugal, and her mother, a women's rights activist in some of Mexico's poorest communities: They taught her to be vocal in the face of injustice. She began her career as a journalist covering arts and entertainment in Cancun, but she quickly turned her attention to the ongoing violence against women in Mexico. In 1999, Cacho Ribeiro was sexually assaulted in a Cancun bus station, an attack that she believes was retaliation for her ongoing series on violence against women. The following year she opened a women's shelter, Centro Integral de Atención a la Mujer, in Cancun for victims of physical and sexual violence.

In 2004, Cacho Ribeiro published her book *The Demons of Eden: The Power Behind Pornography*, in which she discussed unprosecuted alleged abuse of minors by men in power. In response, one of the powerful accused arranged for her arrest on charges of defamation. She was threatened with physical and sexual violence throughout her incarceration but was released shortly after her arrest thanks to the quick work of advocates.

According to Reporters without Borders, Mexico is the third most dangerous country in the world for journalists. In 2012, after years of intimidation, Cacho Ribeiro decided to leave her homeland for London after receiving a death threat on her protected satellite phone. But she is undeterred, and she continues to fight for women worldwide, saying, "Fear is all too real and violence is an efficient means by which to silence people like me. But my strength comes from girls and their power becomes my own."

Tequila: Lemons and Unicorns

Tequila has an Official Mexican Standard setting the boundaries for where and how it can be made. It includes the entire state of Jalisco and municipalities in four other states. Tequila can be made from only one type of agave, the cultivated *A. tequilana Weber Azul*. Over the years, the latitude as to what can be in your bottle of tequila has widened, so we carefully look for a few items on the bottle before purchasing. To ensure you are drinking agave, be sure your bottle says 100% Weber Blue Agave. If you do not see these words, you are about to purchase a *mixto* that may contain only 51% agave sugars. Also, look for the words *Hecho en Mexico* and the letters NOM followed by a four-digit number. This signifies that the bottle you are purchasing was produced in Mexico at a certified distillery. And finally, find a bartender you trust who loves agave and ask for brand suggestions. There are thousands of brands on the market; many carry a hefty price tag, and unfortunately there are more lemons than unicorns. We love agave, and we want you to as well, so choose wisely.

BREAKER OF CHAINS

YIELD: 1 cocktail

Glassware: stemless flute

Garnish: jasmine flower

INGREDIENTS

» 1½ ounces (45 ml) blanco tequila

» ½ ounce (15 ml) lemon juice

» 1 ounce (30 ml) Ginger Lemon Tea Syrup (see below)

» ½ ounce (15 ml) Suze

» splash sparkling white wine

Lemon Ginger Syrup

YIELD: about 1½ cups (350 ml)

» 10 ginger lemon tea bags

» 1 cup (235 ml) hot water

» 1 cup (200 g) sugar

By Rosa Ortiz

Trina's Starlite Lounge, Somerville, MA

Created by Rosa Ortiz, this cocktail is elegant in both flavor and style, with calming notes from homemade ginger lemon tea syrup. "The cocktail is inspired by Ms. Ribeiro's eloquence and calming nature."

DIRECTIONS:

Combine tequila, lemon juice, syrup, and Suze in shaker. Shake and pour into stemless flute; top with sparkling wine. Garnish with jasmine flower.

Syrup

Mix ingredients, stir to make a simple syrup, and steep tea bags for 1 hour.

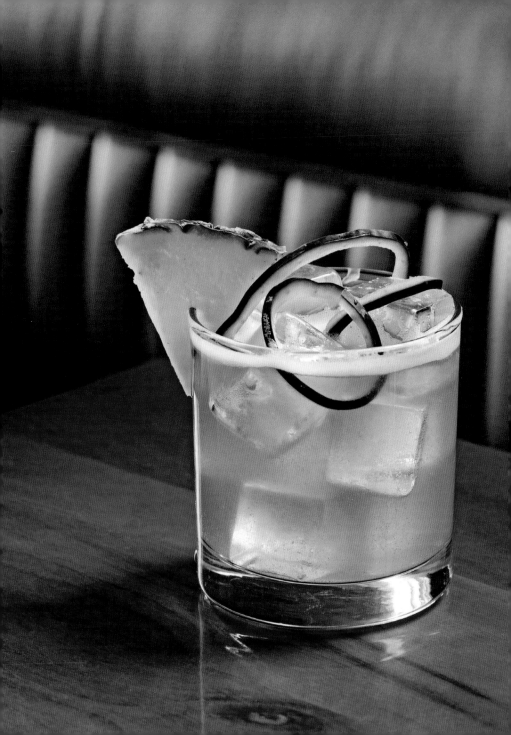

05

CHAPTER

VODKA

We knocked back our share of Cosmopolitans in the early aughts, to be sure, and for many of us, vodka was our gateway spirit, ushering us into cocktails with its approachable neutrality. Make no mistake, though: vodka's neutral nature does not mean it isn't complex. It's in fact the most difficult spirit to taste, and one brand is virtually indistinguishable from another once chilled. Keep a keen eye on marketing, which attempts to convince buyers to spend more on a product for silly reasons. The cocktails in these pages are anything but neutral, with many from vodka's spiritual home in Eastern Europe.

(1899—2002), Yoga Guru/Spiritual Leader
—

Born Eugenie Peterson in Riga, Latvia, in 1899, Indra was the daughter of the head of a Swedish bank and a Russian noblewoman and actress. She was first exposed to yoga at fifteen when she discovered a book, *Fourteen Lessons in Yogi Philosophy and Oriental Occultism*, and she developed a fascination with India and the ancient spiritual practice that would eventually shape her career.

Her family fled Moscow during the Russian Revolution, and her early career was spent working as a dancer and actress in Europe, where she hobnobbed with Theosophists. She moved to India to work as a silent film star under the stage name *Indra Devi*, and she lived the high society life as the wife of a diplomat in India, yet she always yearned for something more. She met the Maharaja and Maharini of Mysore and through them, Sri Tirumalai Krishnamacharya, the father of modern yoga, who refused to take her on as a student because she was a woman and a Westerner. The persuasive

Maharaja eventually won Krishnamacharya over, and Devi was permitted to study, which she did with impressive zeal, right alongside contemporaries K. Pattabhi Jois and B.K.S. Iyengar.

Indra Devi went on to teach yoga in China and in India, where she was the first Westerner to teach the practice, and to author many books. She moved to America and became teacher to the Hollywood glitterati, with Greta Garbo and Eva Gabor among her students.

Later in her career, Devi traveled to Mexico and opened a twenty-four-room estate where she taught yoga teachers. She spent later years in Buenos Aires, where she established the Indra Devi foundation, and was considered a "national treasure." Devi lived to be 102 years old, her center still exists in Argentina today, and her memory lives on.

Cheers to the Indra Devi, groundbreaking spiritual teacher!

Vodka 101

The word *vodka* is derived from the Slavic word *voda* or the Polish word *woda*, both meaning "water." To this day the debate continues as to vodka's origin. The first record of the production of vodka was in Russia at the end of the ninth century. Poland, however, claims to have been distilling vodka since the eighth century.

Vodka is made from neutral spirits. It is typically distilled from grains or potatoes, but there are innovative vodkas on the market these days with all manner of bases, from honey to grapes to milk—yes, milk. The distillation process results in ethanol, also known as ethyl alcohol. The ethanol is then charcoal filtered, rectified, or distilled again to eliminate congeners and achieve a clean, pure taste. Vodka is not aged and, if it is not to be bottled immediately, it is held in glass tanks.

YOUR OWN WAY

YIELD: 1 cocktail

Glassware: collins glass

Garnish: sprig of black currant

INGREDIENTS

» 2 ounces (60 ml) Riga Black Balsam Currant

» Nimbu Pani Soda (see below)

Nimbu Pani Soda

YIELD: about 45 ounces (1.3 L)

» 5 ounces (150 ml) fresh lemon juice

» 40 ounces (1.2 L) water

» 10 spoonfuls granulated sugar

» 1 ounce (30 ml) rosewater

» 1 spoonful salt

By Zhenya Zarukina
El Copitas Bar, St. Petersburg, Russia

Created by Zhenya Zarukina, this cocktail is a nod to Devi's lineage in two ways: Black Currant Riga Balsam hails from her homeland, and Nimbu Pani soda is a refreshing traditional Indian drink.

DIRECTIONS:

Pour Riga Black Balsam Currant and ice into a collins glass. Fill with Nimbu Pani soda, garnish with black currant, and serve.

Nimbu Pani Soda

Combine all ingredients.

(1922—), Actress/Animal Rights Activist

—

B etty White wanted to be a forest ranger when she was little, but women weren't allowed in that field back then. She set her sights on stage and screen instead, and she has had the longest television career of any female entertainer.

Generations know Betty White for her iconic role as the eternally naïve Rose Nylund on *The Golden Girls*, but White got her start in radio. Told by movie studios that she was unphotogenic, she read commercials, played bit parts, and even made crowd noises in her early career, earning $5 a show.

Betty made it on the small screen just as television was getting its start. Her first break was in 1949, as co-host with Al Jarvis on *Hollywood on Television*. It was mostly improvised banter between hosts and the camera. In 1952, she took over as the sole host of the program, airing five-and-a-half hours a day, six days a week.

White started Bandy Productions that year; she would produce and star in her own sitcom *Life with Elizabeth*, described as on par with *I Love Lucy*. At the time, a female producer in TV was unheard-of. White received her first Emmy for the show and her own nationally syndicated *The Betty White Show*, which ran simultaneously and had her working an exhaustive schedule. By 1955, Betty White was America's sweetheart.

White joined the cast of *Mary Tyler Moore* as the man-hungry "happy homemaker" Sue Ann Nivens in 1973, adding dimension to her self-described "icky sweet" image. Her one-episode part evolved into a recurring one by the time she was finished taping. White won two Emmys for her work on *Mary Tyler Moore*.

White's biggest role came with *The Golden Girls*, which ran for seven successful seasons. It earned her an Emmy the first season and a nomination in each subsequent season. In 2010, a Facebook campaign titled "Betty White to Host SNL (Please)" reached 500,000 followers in three months. She hosted that May, at eighty-eight years old—the oldest person ever to host the show. A lifelong animal rights activist, White started a clothing company that sells shirts bearing her image to raise money for animal charities.

In 2010, White was named an honorary forest ranger, finally fulfilling her lifelong dream at ninety years old.

ROSE NYLUND'S VERTUBENFLÜGEN

YIELD: 1 cocktail

Glassware: coupe glass

Garnish: lemon twist and rosemary sprig

INGREDIENTS

» 1½ ounces (45 ml) Cucumber-Infused Vodka (see below)

» ½ ounce (15 ml) Aperol

» 1 ounce (30 ml) Rosemary Syrup (see below)

» 1 ounce (30 ml) lemon juice

» ½ ounce (15 ml) sparkling rosé

Cucumber-Infused Vodka

YIELD: 1 bottle

» 1 bottle vodka

» 2 cucumbers, sliced

Rosemary Syrup

YIELD: about 3 cups (700 ml)

» 2 cups (400 g) granulated sugar

» 6 sprigs rosemary

By Bonnie Nag

Trina's Starlite Lounge, Somerville, MA

"Betty White loves vodka and lemon," says drink creator Bonnie Nag, who incorporates both with rosé and rosemary as a nod to White's most famous character Rose Nylund, "who is sweet, a little naïve, and full of hilarious St. Olaf stories and colloquialisms like 'I'm not one to blow my own vertubenflügen...'"

DIRECTIONS:

Combine Cucumber-Infused Vodka, Aperol, rosemary syrup, and lemon juice in a shaker; add ice and shake until cold. Strain into a coupe glass and top with sparkling rosé. Garnish with a lemon twist and rosemary sprig.

Cucumber-Infused Vodka

Add cucumbers to vodka and let sit for 2 to 3 days, or to taste. Pull out cucumbers once you are satisfied with the flavor.

Syrup

Heat sugar and 2 cups (475 ml) water over medium–low heat, stirring until sugar is dissolved. Do not boil. Once the liquid turns clear, add rosemary. Heat for 5 minutes and remove from heat. Allow liquid to cool. Strain.

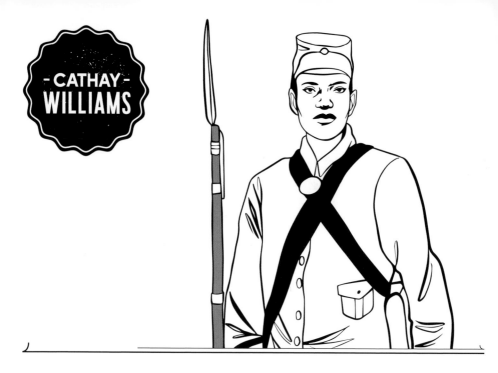

CATHAY WILLIAMS

(1844—c. 1893), Soldier
—

Cathay Williams enlisted in the U.S. Regular Army on November 15, 1866. At the time, women were not permitted to enlist in the military, so she dressed as a man, adopted the alias William Cathay, and marched her way into history.

Very little is known of this mysterious woman. It is unknown whether she was born enslaved or free, or if she was actually twenty-two years old when she enlisted citing her occupation as "cook." Williams was illiterate; therefore, her job prospects were limited to the manual labor roles available to black women, which didn't pay well, making the Army's higher wages an attractive prospect.

Williams was assigned to the 38th U.S. Infantry, one of four segregated African-American units, but her health was a consistent problem. She was in four separate hospitals on five different occasions and no one ever discovered that William Cathay was a woman in disguise. This seems to speak to the quality of healthcare doled out to soldiers back then, or at least to African-American ones. Williams was finally discharged due to her health, with the captain's note describing her as "feeble both physically and mentally, and much of the time, quite unfit for duty." Some historians believe that Williams was living with undiagnosed diabetes. When she applied for a disability pension in 1893, it was denied, despite the fact that she was destitute and all of her toes had been amputated.

Although women disguised themselves as men to serve in the volunteer armies of the Revolutionary and Civil Wars, Williams is the only documented black woman to have served in the Regular Army infantry in the nineteenth century.

THYME BOMB

YIELD: 1 cocktail

Glassware: highball glass

Garnish: sprig of thyme

INGREDIENTS

» 2 ounces (60 ml) Thyme-Infused Vodka (see below)

» 1 ounce (30 ml) Chamomile Simple Syrup (see below)

» ¾ ounce (22 ml) lemon juice

» splash grapefruit juice

» 3 or 4 dashes Angostura bitters

» sparkling wine such as Cava

Thyme-Infused Vodka

YIELD: 1 bottle

» 1 bunch fresh thyme

» 1 bottle vodka

Chamomile Simple Syrup

YIELD: varies

» 1 part chamomile

» 1 part hot water

» 1 part granulated sugar

By Alyssa Shepherd, founding member of LUPEC Boston

Connie & Ted's, Los Angeles, CA

"I played with the herbal (masculine?) and floral (feminine?) qualities in these ingredients," says creator Alyssa Shepherd, a nod to Cathay pretending to be a man to enlist in the army. The combination makes for an herbaceous, sweet, sour, and refreshing drink.

DIRECTIONS:

Shake vodka, simple syrup, and juices. Pour into a highball glass over ice. Add bitters and top with sparkling wine. Garnish with thyme and serve.

Thyme-Infused Vodka

Place thyme in vodka and infuse overnight. Strain into clean bottle.

Syrup

Combine chamomile and hot water. Steep 5 to 10 minutes. Strain, add sugar, and stir until dissolved.

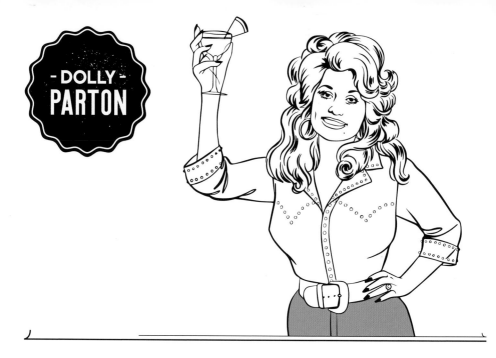

(1946–), Musician/Philanthropist

—

There are many women in this book that push us straight into girlcrush mode. To see us reach fangirl, all you have to do is mention Dolly Parton.

Dolly was born January 19, 1946 in rural Appalachia, the fourth of twelve children. By the age of ten she was performing professionally and in 1959, at the age of thirteen, she made her first appearance at the Grand Ole Opry alongside her uncle Bill Owens. Her rendition of George Jones's "You Gotta Be My Baby" received three encores, sending her on her path to stardom.

Dolly has written more than 3,000 songs in her career. A shrewd businesswoman, she created her own publishing company and record label as soon as she could. This has allowed her to protect the publishing rights of her entire catalog of music throughout her career, including notoriously turning down Elvis Presley's request to share the rights to her hit "I Will Always Love You."

Dolly's music and film careers provide lots of reasons to love her. The Toast Club, however, feels great affinity for her because of her humanity. Dolly is a dedicated philanthropist through donations to multiple causes as well as through her Imagination Library, an organization providing a book a month to families in more than 1,600 communities in the United States, Canada, and the United Kingdom. And Dollywood, her theme park, has rejuvenated the community of Pigeon Forge in rural Tennessee, providing jobs to thousands.

In *Vogue*, an interviewer commented on the diversity of the crowds at her concerts. Dolly responded with, "I want to be accepted myself, and I not only accept, but celebrate, the difference in everyone . . . We need to be a little more accepting, a little more forgiving, a little more harmonious. It can't just be about the person; it has to be about all of us as a whole." Amen, Dolly. Amen.

Aquavit: Water of Life

Deriving its name from the Latin *aqua vitae*, meaning "water of life," aquavit is the spirit of Scandinavia. Aquavit starts on a base of grain or potato and is either distilled three times or infused with aromatics. Caraway is the most common and recognizable spice in aquavit, but each brand is influenced by its local cuisine and customs, so one often experiences dill, fennel, coriander, citrus, and/or anise as well. Aquavit is traditionally served cold and in small doses, frequently alongside pickled or salted fish or as quick refresher mid-meal, but we love it in cocktails! We've got a couple beauties here, and we would also suggest substituting it in for your next brunch Bloody Mary . . . especially if the night before was a tad too indulgent. The aromatics will help to calm your queasies and get you back on track.

BURLAP AND SATIN

YIELD: 1 cocktail

Glassware: 8 ounce (240 ml) double rocks glass

Garnish: pineapple quarter, skin on, and cucumber noodles

INGREDIENTS

» 1½ ounces (45 ml) Krogstad Aquavit

» 1 ounce (30 ml) pineapple juice

» ¾ ounce (22 ml) lemon juice

» ½ ounce (15 ml) Aperol

» ½ ounce (15 ml) simple syrup

By Rhachel Shaw

Harvard & Stone, Los Angeles, CA

"I secretly think she's a Viking," says creator Rhachel Shaw of her inspirational lady, "so I used Aquavit for this one." Pineapple juice and Aperol make for a drink that is sweet, sour, balanced with a touch of bitterness, and brightly hued.

DIRECTIONS:

Combine ingredients in a shaker and shake. Strain over fresh ice. Garnish with pineapple quarter and cucumber noodles and serve.

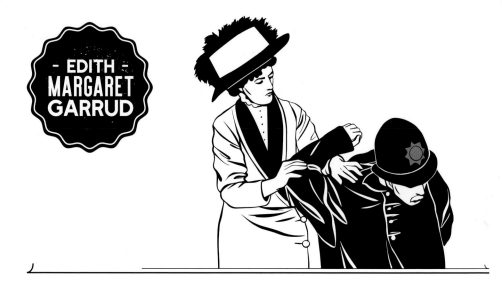

EDITH MARGARET GARRUD

(1872–1971), Suffragette/Martial Artist
—

Those of us raised in the United States most likely recall the stereotypical image of a suffragette from our school history textbooks: a middle-aged woman in modest dress bearing a placard walking down a street. What would that image be for our Toast Club sisters across the pond? Most likely a practitioner of jujitsu, thanks to Edith Margaret Garrud.

Garrud and her husband were introduced to jujitsu in 1872 by Edward William Barton-Wright, the first instructor of the discipline in Europe, and went on to study with one of the first Japanese instructors to teach jujitsu outside of Japan, Sadakazu Uyenishi. When Uyenishi returned to Japan in 1908, Garrud and her husband assumed responsibility for his dojo, Golden Square. They were invited to the Women's Social and Political Union (WSPU) by Emmeline Pankhurst to introduce self-defense moves to the members. Garrud's husband fell ill, so she attended the meeting, starting a long relationship training the WSPU. The jujitsu trainings were first intended to provide a means to manage hecklers. However, as tensions rose, the trainings began to include methods of fighting back. Jujitsu uses the attacker's force against them. By channeling the attacker's momentum and using pressure points, a practitioner can fend off a much larger assailant, which made it a perfect application for the suffragettes.

In 1913, Garrud organized the 30-member Bodyguard of the WSPU in response to the Cat and Mouse Act, an act that called for releasing hunger strikers and then arresting them once again when they had regained their strength. The Bodyguard, or the Suffrajitsu, as they were nicknamed in satirical cartoons, trained in secret locations around London and concealed wooden clubs, which they would use to protect their members from rearrest, in their dresses.

At four feet, eleven inches (1.5 m) tall, Garrud was an unexpected package of power and therefore a fitting asset to the unpredictable women of the WSPU and the suffragette movement. We raise this toast to women who raised their voices, and sometimes their fists, for the right to vote.

> Woman is exposed to many perils nowadays, because so many who call themselves men are not worthy of that exalted title, and it is her duty to learn how to defend herself.

—EDITH MARGARET GARRUD

DZHUYFFRAGETTE

YIELD: 1 cocktail

Glassware: coupe glass

Garnish: lime zest

INGREDIENTS

» 2 ounces (60 ml) Chili-Infused Vodka (see below)

» ¾ ounce (22 ml) Green Chartreuse

» 1 ounce (30 ml) lime juice

» ¼ ounce (8 ml) Honey Syrup (see below)

Chili-Infused Vodka

YIELD: 1 quart (1 L)

» 1 quart (1 L) vodka
» 1 large or 5 small chili peppers, chopped

Honey Syrup

YIELD: 15 ounces (440 ml)

» 8½ ounces (250 ml) honey
» 6½ ounces (190 ml) hot water

By Katerina Babich

Tipplers Bar, Saint Petersburg, Russia

Creator Katerina Babich created this riff on a classic White Lady cocktail: "Sharp and strong like Lady Edith Margaret Garrud, it will cheer up the body and spirit, like her martial arts."

DIRECTIONS:

Combine all ingredients, shake, and strain into a cocktail glass. Garnish with lime zest and serve.

Chili-Infused Vodka

Combine vodka and chilis in a non-reactive container. Strain after 1 day.

Syrup

Stir honey and water together until incorporated.

FRANCES -GABE-

(1915—2016), Inventor

—

Ugh, housework. We will try anything and spend any amount of money to make it easier, to make it take less time, or to have it go away completely. Frances Gabe went one step further, spending forty years to develop a solution she lived in.

Frances Gabe was born in Boise, Idaho, where her father was a house builder. Her schooling was split between public education and home schooling, which allowed her the opportunity to spend days with her father on job sites. His crews became her second family and happily taught her about building. At age twelve, Gabe was enrolled in the Girls Polytechnic School in Portland, Oregon, where she handily completed six years of middle and high school in only two years.

Gabe married and had three children before separating from her husband, becoming the sole supporter of her family. Desperate to spend her free time with her children rather than mopping her floor, Gabe commenced a forty-year journey toward building a self-cleaning home.

The 1,350 sq ft (125 sq m) house boasted self-cleaning rooms that could spray-wash, rinse, and dry themselves with air currents in an hour. Floors, walls, furniture, and upholstery were made using waterproof materials, and beds were protected by a sheet that was unrolled from headboard to foot prior to starting the cleaning cycle. The floors were constructed using adjustable joists, allowing for perfectly tilted floors to direct cleaning water into floor drains even when the house had settled years after construction. In total, Gabe and her self-cleaning house were responsible for sixty-eight patents.

What we love most about Gabe is that the development of her house wasn't because she hated doing the laundry, but because she wanted to spend more time with the people she cared about. "We should be better mothers, wives, neighbors, and spend time improving ourselves instead of saying, 'I'm sorry, I have to clean the kitchen.'" In honor of Gabe, we would like you to share this cocktail with the ones you love.

WATERFALL

YIELD: 1 cocktail

Glassware: highball glass

Garnish: lavender sprig

INGREDIENTS

» 1¼ ounces (37 ml) Lavender-Infused Vodka (see below)

» ½ ounce (15 ml) Lillet Blanc

» ½ ounce (15 ml) verjus

» Carrot and Orange Skin Soda (see below)

Carrot and Orange Skin Soda

YIELD: 15 ounces (440 ml)

» 6 carrots

» 5 oranges

» 1 cup (200 g) sugar

» ⅓ cup (80 ml) soda water

Lavender-Infused Vodka

YIELD: 1 bottle

» 1 bunch fresh lavender

» 1 bottle vodka

By Grazia Difranco

PS 40, Sydney, Australia

Drink creator Grazia Difranco was inspired by the mechanisms of Frances Gabe's self-cleaning house: "small waterfalls" in the house and her clothes cabinet, which "in my mind, smells like fresh and gentle lavender." Carrot and orange are a nod to Gabe's health and longevity; she lived to be 101.

DIRECTIONS:

Combine vodka, Lillet Blanc, and verjus in a strainer with ice and shake. Strain over ice. Top with soda. Garnish with lavender sprig and serve.

Soda

Peel oranges and carrots and then cut carrots into thin strips. Put carrots and oranges in a jar and cover with sugar. Allow to sit for 2 days, until the oils of the oranges and carrots dissolve the sugar, then strain the "syrup." To every 1¼ tablespoon (20 ml) of the syrup, add ⅓ cup (80 ml) soda water. If the soda is light in flavor, add a mixture of 2 parts carrot and 1 part orange juice until you are pleased with the flavor.

Lavender-Infused Vodka

Place the lavender into the vodka bottle and allow to infuse overnight. Strain and transfer to a clean bottle.

(1815—1852), Mathematician/Programmer
—

Ada Lovelace was a woman 110 years ahead of her time. In 1843, she wrote what many consider to be the first computer program, more than a century before the computer would be invented.

Born Augusta Ada Byron in 1815, she came to be called Ada by her father, the famous poet and womanizer Lord Byron. Byron left Ada and her mother, Annabella Milbanke, just weeks after she was born, and Ada would never know him. Determined that Ada not develop the "insanity" her father possessed, Annabella encouraged Ada's tutoring in math and sciences. She was herself a math whiz, called the "Princess of Parallelograms" by Lord Byron.

Ada Lovelace would earn her math-y nickname, the Enchantress of Numbers, from her mentor, Charles Babbage, the father of computing. Ada was tutored by Mary Somerville, one of the first women to be admitted into the Royal Astronomical Society, who introduced Ada to Babbage when she was seventeen. Ada became fascinated with his difference engine, a tower of numbered wheels that could produce reliable calculations.

Lovelace's contribution to science came when Babbage had her translate an article about his new invention, the analytic engine, from French to English in 1843. Ada's version, with notes, was three times as long as the original article, and published under "AAL" in an attempt to avoid gender-based stigmatization. In the Note G section, she describes a pattern that is known today as "looping," which is regarded as the first computer program.

Lovelace's work was unnoticed beyond her scientific circle, but it would be re-published in 1953, profoundly influencing modern computing. Although some dismiss her work as irrelevant, that she was able to interpret the analytic machine as much more than Babbage's vision of a number-cruncher is irrefutable.

> **Lovelace's contribution to science came when Babbage had her translate an article about his new invention, the analytic engine, from French to English in 1843.**

NOTE G

YIELD: 1 cocktail

Glassware: chilled coupe glass

Garnish: lemon peel

INGREDIENTS

- » ¾ ounce (22 ml) Belvedere Intense vodka
- » ¾ ounce (22 ml) Grey Goose vodka
- » ½ ounce (15 ml) Gancia dry vermouth
- » ½ ounce (15 ml) Lustau Palo Cortado sherry
- » ¼ ounce (8 ml) Cocchi Americano
- » ¼ ounce (8 ml) Lustau fino sherry

By Cari Hah

Big Bar, Los Angeles, CA

Creator Cari Hah got real math-y in this homage: "I personally love a 50/50 cocktail because within the realm of the 50/50, I can split up that fraction with whatever kind of ingredients I want! This cocktail is a mathematical cocktail and a damn tasty rendition!"

DIRECTIONS:

Combine all ingredients in a mixing glass and stir, strain into a chilled coupe glass, and express lemon peel over top. Serve.

RUTH BADER GINSBURG

(1933–), Supreme Court Justice
—

"**I**f you're going to change things, you have to be with the people who hold the levers." Rising from one of eight women in a Harvard Law School class of 500 to the second female justice on the Supreme Court, Ruth Bader Ginsburg is not only with the people who hold the levers, she is a person holding a lever.

When you consider the details of the life of Ginsburg, it becomes apparent why she is committed to the cause of equality. From being demoted from her position at the Social Security Administration when she became pregnant at the age of twenty-one to being asked by a Harvard Law professor how she could justify taking a spot in the class away from a qualified man, Ginsburg's experiences have shaped her loyalties. Despite these adversities, her resume boasts a list of firsts. After graduating first in her class from Cornell University, she became the first female member of the Harvard Law Review. In 1959, she graduated first in her class at Columbia Law School, where she would eventually become the first female tenured professor.

In 1970, Ginsburg founded *The Women's Rights Law Reporter*, the first law journal focused exclusively on women's rights, and in 1972 she founded the Women's Rights Project at the ACLU, which works toward change and reform in institutions that perpetuate discrimination against women. By 1974, the ACLU and the WRP had prosecuted more than 300 gender discrimination cases.

Ginsburg was appointed to the Supreme Court in 1993 by President Bill Clinton and was confirmed by a 96-3 vote. Perhaps her most well-known dissent was in the case of *Ledbetter v. Goodyear*. Ledbetter sued Goodyear because she made significantly less than her male counterparts. She was denied relief in the court due to statute of limitations. Ginsburg went on to work with President Obama to pen the Lilly Ledbetter Fair Pay Act, which was the first piece of legislation signed by President Obama in 2009.

In honor of Her Honor, we raise this toast!

WHEN THERE ARE 9

YIELD: 1 cocktail

Glassware: rocks glass

Garnish: orange oil

INGREDIENTS

» 1 ounce (30 ml) Lysholm Linie Aquavit

» 1 ounce (30 ml) Lingonberry-Infused Campari (see below)

» 1 ounce (30 ml) sweet vermouth

Lingonberry-Infused Campari

YIELD: 1 bottle

» 7 ounces (200 g) fresh or frozen lingonberries

» 1 bottle Campari

By Monica Berg

Taxonomy Ltd, London, England

In a nod to RGB's continuing fight for equality, Monica Berg created a three-ingredient equal-part cocktail, saying "as with life, this drink only works if the ingredients are equal!"

DIRECTIONS:

Stir on ice, strain into a rocks glass with one large ice chunk or ice cubes. Orange oil garnish.

Lingonberry-Infused Campari

In a nonreactive container, combine ingredients and leave to infuse for 48 hours at room temperature. If you want a more delicate and fruity drink, try to let the berries infuse gently without breaking the skin too much. If you want a juicier and richer drink, make sure to press the berries a little so the skins break.

Strain through a superbag or cheesecloth. Rebottle the infused Campari and store at a cool temperature when not in use.

If you have time, transfer the leftover lingonberries to a pan, add ¼ cup (50 g) superfine sugar, and bring to a boil. Let simmer for 5 minutes, let cool, and transfer to a pasteurized glass container. Hello Campari and Lingonberry Jam!

06

COGNAC, BRANDY, AND PISCO

Brandy smacks of old world elegance—think of the rich tycoon in practically any 1980s movie, sitting down with a snifter and sucking on a cigar. Fear not, intrepid drinker! Brandy also lends itself to some of our favorite cocktails. It derives its name from the Dutch word brandivijn, meaning "burnt wine," and is a category that includes anything distilled from fermented fruit juice. This broad term casts a wide net that encompasses everything from Armagnac to slivovitz. Just about every culture has a delicious brandy that is made from the local, readily available fruit and provides the base for regionally inspired tipples. Read on for some innovative drinks with this elegant, worldly spirit!

(1911—2016),
Journalist/Photographer/Humanitarian
—

If the Toast Club were to illustrate the dictionary, there is no doubt in our minds that we would place an image of Ruth Gruber aside the entry for *overachiever*. At fifteen, she entered New York University, at nineteen she received a master's in German from the University of Wisconsin, Madison, and in 1931, at the age of twenty, she became the youngest person in the world to receive a Ph.D., graduating magnum cum laude from Cologne University with a doctorate in German literature. And she was just getting started.

Gruber's academic achievements were remarkable, but the timing of those achievements had perhaps an even greater impact on the rest of her career. During her Ph.D. studies in Cologne, Gruber observed the burgeoning Nazi party and recognized the dangers that could come with a fascist regime. At the age of twenty-four, she became a photojournalist and spent her life documenting some of the most remarkable events of the twentieth century.

During World War II, Gruber was made a special assistant to Secretary of the Interior Harold Ickes. In 1944, she was commissioned as a secret agent to Italy to escort 1,000 Jewish refugees from nineteen nations as well as injured American soldiers to the U.S. Sent with the title of "simulated general," Gruber would be protected under the Geneva Convention if she were captured by enemy forces. On the journey back, Gruber interviewed those she accompanied, saying, "You are the first witnesses to come to America. Through you, America will learn the truth of Hitler's crimes."

Gruber covered more than seven decades of history as a journalist and continued to share her experiences long after she retired, including completing a twenty-city tour at the age of ninety to celebrate the reprinting of four of her nineteen books. Ruth lived to 105, leaving behind the secret to her success: "Have dreams, have visions, and let no obstacle stop you."

Cognac 101

Cognac is the most well-known type of brandy due to its global reach and its stellar quality. Protected by a Denomination of Origin, Cognac is produced in the wine-growing region of France around the town of the same name and has six distinct growing regions. There are several wines that can be used for the production of Cognac, but Ugni Blanc is by far the most prominent. As our mentors once said, this wine is poor for drinking but great for distilling. The production methods of Cognac are closely regulated. All Cognacs are distilled twice in small copper pot stills. This is then aged in either Limousin or Tronçais oak casks for a minimum of two years. When aged longer, it receives special aged statements to designate the time in barrel: VS for a minimum of 2½ years, VSOP for a minimum of 4½ years, or XO for a minimum of 6 years.

YIELD: 1 cocktail

Glassware: 12 ounce (350 ml) double Old Fashioned glass

Glassware: orange peel

INGREDIENTS

» 1 ounce (30 ml) Pierre Ferrand Ambre Cognac

» 1 ounce (30 ml) Roger Groult 6 Year Old Calvados

» ½ ounce (15 ml) Hidalgo Pedro Ximenez sherry

» 3 dashes Angostura bitters

By Phoebe Esmon

Nightbell & Curate, Asheville, NC

Those who were led to safety by Gruber called her "Mother Ruth," which inspired Phoebe to create this cocktail based on the flavors of the comfort food rugelach. "The name Miriam's Cup was taken from a feminist focused addition to the traditional Seder."

DIRECTIONS:

Combine ingredients in a mixing glass, add ice, stir, and pour into a double Old Fashioned glass. Add 1 large piece of ice, garnish with orange peel, and serve.

- CARLA - HAYDEN

(1952–), Presidential Librarian

—

Librarian stereotypes abound with some iteration of a glasses-wearing, bun-sporting spinster who, from her post behind the circulation desk, maintains the decorum of the hallowed stacks. Carla Hayden, Ph.D., would be the first to tell you that the true librarian is a soldier for freedom and privacy.

Dr. Hayden began her career in libraries in Pittsburgh and Chicago and has helmed the Baltimore library system since 1993, widening its role from simply a book lending organization to the center of community activism and conversations. In 2015, during the protests over the death of Freddie Gray, Hayden chose to keep the library closest to the demonstrations open even as schools and other institutions were shuttering, creating a place of refuge for comfort and discussion.

In 2003, Hayden was appointed President of the American Library Association, the oldest and largest library association in the world that has more than 57,000 members. During her yearlong tenure,

Hayden turned word-warrior, going head-to-head with then-Attorney General John Ashcroft's attempts to use the Patriot Act to override the privacy laws that protect information about your library use. Arguing that there is a difference between interest and intent, Hayden said, "Just because you're interested in what jihad is doesn't mean you intend to join."

In 2016, Dr. Hayden was sworn in as the fourteenth Librarian of Congress, the first woman and the first African-American to hold the post. In an industry in which 85 percent of the workforce is female and yet the majority of management is male, her appointment to this most significant role in the field sends a message of encouragement. At the same time, Hayden continues to exhibit what she sees to be the core value of libraries, inclusiveness, saying that she wants the Library of Congress "to get to the point where there'll still be a specialness, but I don't want it to be an exclusiveness. It should feel very special because it is very special. But it should be very familiar."

Being the first female and the first African-American means that the legacy of the fourteen Librarians of Congress will include diversity—and also a female in a female-dominated profession.

—CARLA HAYDEN

ꝐAYDEN 020

YIELD: 1 cocktail

Glassware: 6 ounce (175 ml) coupe glass

Garnish: lemon twist

INGREDIENTS

» 2 ounces (60 ml) Laird's Straight Apple Brandy

» ¾ ounce (22 ml) amontillado sherry

» ¾ ounce (22 ml) Apple Simple Syrup (see below)

» ¾ ounce (22 ml) fresh lemon juice

Apple Simple Syrup

» 1 cup (235 ml) 100% apple juice

» 1 cup (200 g) sugar

By Jill Cockson

Swordfish Tom's, Kansas City, MO

Hayden 020 is a thoughtful toast, from its name, a nod to the Dewey Decimal section dedicated to library science, to its aroma. "The scent of dry sherry is, to me, reminiscent of wet, old paper with just a hint of must," reminding creator Jill Cockson of a used bookstore or library.

DIRECTIONS:

Shake ingredients with ice, strain, and garnish with a lemon twist. Serve.

Apple Simple Syrup

Combine apple juice and sugar over low heat until sugar has dissolved. Allow to cool. Keep up to 7 days in refrigerator.

DOROTHY LAWRENCE

(1896–1964), Journalist

—

As a journalist in England, Dorothy Lawrence dreamed of being a war correspondent. When World War I commenced she was living in France, where she seized the opportunity to offer her services, wishing to cover the battlefields of the Western Front for British newspapers. Every organization balked at the idea, stating that the war arena was much too dangerous. An undaunted Lawrence took matters into her own hands, befriending two British soldiers in a Paris cafe and convincing them to smuggle her a uniform piece by piece. Outfitted with her secondhand duds, Lawrence cut off her hair, bound her breasts, scraped her cheeks with a razor to simulate razor burn, and learned the military drills and marches. She christened herself Private Denis Smith of the 1st Battalion Leicestershire

Regiment and forged papers to match. Assisted by a combat engineer named Tom Dunn, Private Denis Smith made it to within 400 yards (365 m) of the German trenches, laying mines in no-man's-land as munitions hailed down. Lawrence spent ten days on the dangerous front before she started having fainting spells and revealed her true identity to military authorities. Incredulous that a woman could infiltrate their ranks, the officials first assumed she must be either a spy or a prostitute.

Lawrence penned a memoir of her battlefield subterfuge, *Sapper Dorothy Lawrence: The Only English Woman Soldier*, but the military insisted upon censoring a large portion of the book, concerned that other women would try to emulate Lawrence's incredible feat.

> **Lawrence spent ten days on the dangerous front before she started having fainting spells and revealed her true identity to military authorities.**

SAPPERS

YIELD: 1 cocktail

Glassware: 6 ounce (175 ml) coupe glass

Garnish: lime zest

INGREDIENTS

» 1⅔ (50 ml) pisco, preferably Peruvian

» ⅔ ounce (20 ml) St-Germain

» ⅓ ounce (10 ml) Suze

» 1 ounce (30 ml) fresh grapefruit juice

» ⅔ ounce (20 ml) fresh lime juice

» ⅓ ounce (10 ml) white sugar

By Sheena Jacques-Galan
Carry Nation, Paris, France

Although built on the base of a Peruvian pisco, the modifiers of Sheena's Sappers include some of our favorite French aperitifs, making this the perfect toast to a woman whose subterfuge started tableside at a Parisian café.

DIRECTIONS:

Shake ingredients with ice and strain. Serve.

THE LADY - OF CAO -

(approx. 450 CE), Priestess Queen

—

Before the Inca Empire dominated the Andes, and long before Europeans arrived in Latin America, the Moche Culture lived in the Chicama Valley. From around 100 to 700 CE, they thrived, building irrigation canals to raise their crops and becoming skilled artisans of ceramics and gold.

In 2006, deep in the bottom of a sacred tomb, the mummified body of the Lady of Cao was discovered, shattering notions that the Moche culture was patriarchal. The richness of the jewels, gems, and weapons laid in the Lady of Cao's tomb indicate her position was of very high rank, a priestess Queen. The tombs of eight women of equally high rank were subsequently discovered.

The Lady of Cao's skin was exceptionally preserved, most likely due to the use of copious amounts of cinnabar, a mineral associated with the life source of blood, and a known antimicrobial agent. Her skin was copiously tattooed on the arms, hands, legs, and feet, with serpents, spiders, and crabs, all animals associated with the pantheon of divine creatures of the Moche. The symbology increased the image of her power among her people, with the divine living on her skin.

Lady Cao died in her twenties in childbirth, but her legacy lives on 1,700 years later!

> **The richness of the jewels, gems, and weapons laid in the Lady of Cao's tomb indicate her position was of very high rank, a priestess Queen.**

BLOSSOM & SIX

YIELD: 1 cocktail

Glassware: 12-ounce (350 ml) wineglass

Garnish: lemon twist

INGREDIENTS

» 1½ ounces (45 ml) pisco

» ¾ ounce (22 ml) grapefruit juice

» ¾ ounce (22 ml) peach liqueur

» 2 ounces (60 ml) chilled hibiscus tea

» 1 ounce (30 ml) club soda

By Meaghan Dorman
Raines Law Room, The Bennett, and Dear Irving,
New York, NY

To toast the Lady of Cao, Meaghan Dorman combined flavors that reminded her of the lush rainforests of Peru, including hibiscus and peach. The resulting cocktail is a beautiful color invoking "a tapestry or cloth such as a high-ranking lady might own."

DIRECTIONS:

Combine all ingredients except club soda in a shaker. Roll ingredients with ice and dump into wineglass. Top with club soda and garnish with lemon twist. Express oil, twist up pretty, and serve!

**(1907–1964),
Marine Biologist/Environmental Activist**

—

Environmental activism is a shockingly uphill battle these days, despite near unanimous consensus in the scientific community that human impact on the environment is real and dangerous. Who knows if we'd have gotten even this far without Rachel Carson and the precursive power of her pen.

Carson grew up on a farm in Pennsylvania. She fell in love with nature at an early age and was a gifted young writer who wrote stories for children's magazines. Carson received a master's in zoology from Johns Hopkins University in 1932, and she went on to become the second female hire at the U.S. Bureau of Fisheries, with whom she had a fifteen-year career at the U.S. Fish and Wildlife Service.

Carson turned her government research into beautifully written, accessible, non-technical prose that positions mankind as an integral part of the ecosystem we inhabit and questions the notion that

nature was meant to be dominated. Her three books about marine biology, *Under the Sea Wind* (1941), *The Sea Around Us* (1951), and *The Edge of the Sea* (1955), are described as a biography of the ocean. *The Sea Around Us* was a bestseller and secured her financial freedom.

Carson's most influential work, *Silent Spring*, was published in 1962 and addressed the impact of pesticides on ecosystems, connecting their use to cancer in humans. She called out chemical companies for lying about the safety of their products to scathing criticism from business leaders and even members of government. Her seminal work led to a presidential commission that supported her findings and a new era in environmental consciousness.

Here's to you, Rachel Carson! Mother Earth needs you now more than ever!

TURN THIS MESS AROUND

YIELD: 1 cocktail

Glassware: 6 to 8-ounce (175 to 235 ml) rocks glass

Garnish: orange oil

INGREDIENTS

» 1½ ounces (45 ml) Laird's Apple Brandy

» ¼ ounce (8 ml) Del Maguey Vida Mezcal

» ½ ounce (15 ml) Dolin blanc vermouth

» ½ ounce (15 ml) Cranberry Shrub (see below)

» 2 drops Saline Solution (see below)

» 1 large orange twist

Cranberry Shrub

YIELD: about 2 cups (475 ml)

» 12 ounces (340 g) fresh cranberries

» 12 ounces (340 g) granulated sugar

» 5 allspice berries

» 5 juniper berries

» 2 black peppercorns

» 12 ounces (250 ml) Catskill Provisions unfiltered Apple Cider Vinegar

Saline Solution

YIELD: 3⅓ ounces (100 ml)

» 1 tablespoon (20 g) kosher salt

» 3⅓ ounces (100 ml) hot water

By Mimi Burnham
Bartender-at-large, New York, NY

Mimi's toast to Rachel Carson includes flavors that hark back to events in Rachel Carson's life, from the saline solution, which reminds us of her work to save the oceans, to the sharp note of cider vinegar in the shrub, symbolizing her fights against the chemical companies, to the dash of mezcal "to bring a smoky back note, as a tribute to a beach campfire, which I imagined Rachel may have enjoyed."

DIRECTIONS:

Stir ingredients with ice in a mixing glass and strain into a rocks glass. Garnish with orange oil and serve.

Shrub

Place cranberries, sugar, allspice, juniper, and peppercorns in a nonreactive bowl or container, hand-crushing the allspice, juniper, and peppercorns to break their skins. Toss to coat all the cranberries and spices as evenly as possible with the sugar. Cover and refrigerate overnight, or at least 8 to 10 hours.

Gently press cranberries to remove remaining juices and strain into a clean glass jar with a tight lid. Take care to scrape any remaining sugar and strain into the liquid. Add cider vinegar and stir to thoroughly combine.

The shrub is now ready for use and must be refrigerated, but the flavors will change and gather more depth after a week or two of sitting. It has a very long shelf life if kept properly refrigerated.

You may find that periodic shaking of the refrigerated shrub will result in a more balanced flavor, as some settling may occur.

Saline Solution

Combine salt with water and stir until dissolved. Use an eyedropper to add droplets.

HARRIET CHALMERS ADAMS

(1875—1937), Explorer

—

H arriet Chalmers Adams logged 100,000 travel hours at the turn of the century, without the aid of trains, cars, or in some cases even roads!

Adams was born October 22, 1875 to adventure-seeking parents. While her mother and sister summered at a resort, her father explored the west coast with young Harriet as his sidekick. They covered the Sierras from Oregon to Mexico on horseback "when the high places, now well known, were virtually unexplored."

Adams's partner in life and adventure was Franklin Pierce Adams, a mine engineer who turned a three-year-long work trip to Latin America into a 40,000 mile couple's expedition. They traversed the Andes four times on horseback, visiting every country on the continent. She is believed to be the first white woman to meet twenty indigenous South American tribes, indicating the remoteness of their explorations.

Adams kept a diary and took great photographs, which landed her a gig writing for *National Geographic* upon returning to the U.S.; she was the most prolific female contributor at the time. She was an excellent writer, turning her stories and color photographs into lectures that earned her fame, notoriety, and many speaking gigs. Adams was the keynote speaker at the Pan-American Women's Conference in 1922, and was inducted into the prestigious British Royal Geographic Society in 1913. When she was shut out from joining the American counterpart, the Explorer's Club, she started the Society of Women Geographers in 1925.

Pisco Primer

Pisco is a distilled grape spirit that hails from Peru or Chile and is made from unique regional varietals. It's born much in the same way as Cognac or brandy but is aged in stainless steel versus wood so typically has little to no discernible color. As a category, pisco emphasizes place over process, allowing flavors of the grape to shine through by using stainless steel instead of wood for aging.

LA PATRIA

YIELD: 1 cocktail

Glassware: 4 ounce (120 ml) Nick & Nora glass with a dividend*

Garnish: pansy

INGREDIENTS

» 1½ ounces (45 ml) Singani 63

» ¾ ounce (22 ml) verjus

» ¼ ounce (8 ml) strawberry liqueur

» ¼ ounce (8 ml) Batavia Arrack

» dash absinthe

By Ivy Mix

Leyenda, New York, NY

Ivy Mix worked with Bolivian spirit and Batavia Arrak, a nod to Adams's travels in exotic locales in South America and across Europe, sweetened with strawberry and balanced with verjus for a sweet, sour cocktail.

DIRECTIONS:

Stir all ingredients in a mixing glass and strain into a glass. Garnish with a pansy and serve.

*Serving a drink with a dividend means serving the leftover cocktail smartly on the side in a separate vessel, ready to replenish your glass. The cleverest bartenders find a way to nestle it into a bed of crushed ice to keep the little "sidekick" chilled but not diluted.

(1979—), Journalist/Activist

—

In 2011, Tawakkol Abdel-Salam Karman became the first Yemeni, the first Arab female, and the second Muslim woman to win a Nobel Prize for Peace—not bad for a thirty-two-year-old activist. Karman grew up during a tumultuous period in Yemen, ushering in an era of dissidence in the south and an oppressive northern-ruled regime. A journalist by trade, Karman turned to activism and reporting on the many human rights abuses occurring around her. She founded Women Journalists Without Chains (WJWC) in 2005 to teach her trade to fellow women and advocate for freedom and other inalienable rights.

From 2007 to 2011, Tawakkol organized weekly protests in Yemen's capital against systemic government repression. In 2011, Tawakkol encouraged protesters to shift their weekly support to the Arab Spring. She has been imprisoned multiple times over her pro-democracy, pro-human rights activities, and she has received numerous threats on her life.

She was awarded the Nobel Peace Prize in 2011, honoring her work in nonviolent struggle for the safety of women and for women's full rights to participate in peace-building initiatives.

Cheers to Tawakkol; we can't wait to see what the next thirty-two years bring!

GOOD GOVERNANCE

YIELD: 1 cocktail

Glassware: Nick & Nora glass

Garnish: mint leaf

INGREDIENTS

» 1 ounce (30 ml) El Maestro Sierra Brandy Solera Reserva

» 1 ounce (30 ml) Cardamaro

» ½ ounce (15 ml) Black Tea and Cardamom Syrup (see below)

» ½ ounce (15 ml) fresh lemon juice

Black Tea and Cardamom Syrup

YIELD: varies

» black tea

» 8 ounces (240 ml) boiling water

» 2 green cardamom pods

» granulated sugar

By Katie Rose
Goodkind, Milwaukee, WI

Katie's toast to Tawakkol Abdel-Salam Karman incorporates flavors of Yemen, including tea, cardamom, and mint, as well as the fig and fenugreek notes of her chosen brandy. "In an attempt at making a drink that was formidable in its nature, but spoke wisely and eloquently with its voice, I hope I was able to represent her passion and prowess."

DIRECTIONS:

Combine ingredients in a shaker with ice, shake, and strain into a Nick & Nora glass. Garnish with a mint leaf and serve.

Black Tea and Cardamom Syrup

Combine 1 bag black tea with 8 ounces (240 ml) piping hot water and 2 cardamom pods. Take the tea out after 5 minutes but let the cardamom pods remain. Allow mixture to cool to room temperature and strain.

Measure black tea/cardamom mixture, transfer to a saucepan, add equal amount of sugar, and bring to a simmer over medium heat until sugar is completely dissolved. Allow to cool, bottle, and store in the refrigerator.

- MABEL -
NORMAND

(1892–1930), Actress/Director

—

Mabel Normand was the most famous comedic actress for a spell, while Hollywood was still a nascent industry.

Normand modeled for Charles Dana Gibson, creator of the Gibson Girl, before becoming one of the first leading ladies to appear in film without a theater background. She solidified her style as a slapstick comedienne, discovering and performing alongside Charlie Chaplin, his leading lady and mentor.

In 1913, *Moving Picture World* reported that Keystone's leading lady Normand was "in the future to direct every picture she acts in." Director credits were frequently either not listed or given to her co-stars with each reissue of a studio's films, making this impossible to verify, but Normand listed her occupation as "director" in the Los Angeles city directory starting in 1914. Notably, Normand was one of the first leading ladies to have her name used in her films' titles. She launched Mabel Normand Feature Film Company in 1916.

Normand's rising star fizzled abruptly in the 1920s amidst several Hollywood scandals. Her close friend William Desmond Taylor was murdered in 1922 after enjoying Orange Blossom gin cocktails and conversation with Normand in the early evening, and although she was never a suspect, she was the last person to see him alive. In 1924, Normand was at a party when friend Courtland S. Dines was shot in a completely unrelated incident; Normand became associated with sensationalized media attacks on Hollywood's "immorality," decimating her career.

Cheers to Mabel Normand, icon of silent film!

SILENT RED

YIELD: 1 cocktail

Glassware: 6-ounce (175 ml) martini glass

Garnish: orange

INGREDIENTS

» 2 ounces (60 ml) aged Chilean pisco

» 1 ounce (30 ml) filtered beetroot juice

» 1 ounce (30 ml) rose syrup such as Giffard or Monin (or see below)

» ½ ounce (15 ml) Macerated Pisco with Earl Grey Tea (see below)

» orange peel

Rose Syrup

YIELD: about 1½ cup (350 ml)

» ⅘ cup (200 ml) water

» ⅕ ounce (5 g) rose tea

» 1 cup (200 g) granulated sugar

Macerated Pisco with Earl Grey Tea

YIELD: about 8 ounces (235 ml)

» 5 ounces (150 ml) aged pisco

» 3½ ounces (100 g) Earl Grey tea

By Chabi Cadiz
Prima Bar, Santiago, Chile

Chabi Cadiz is inspired by simple things that can have great effects. For her Silent Red, she was inspired by the styles of 1920s makeup, especially bright red lipstick that would allow for dramatic effect even in a black and white film.

DIRECTIONS:

Combine ingredients in a mixing glass with ice, shake, and strain into a martini glass. Garnish with orange and serve.

Syrup

Bring ingredients to a boil in a saucepan, cool, filter, and bottle. Syrup will keep 1 to 2 weeks refrigerated.

Macerated Pisco with Earl Grey Tea

Combine pisco and tea and macerate for 2 weeks in a dark, dry place. Filter and enjoy.

07

PUNCH!

AND LOW-ALCOHOL TIPPLES

As we hope we've illustrated thus far, you can toast any occasion by raising a glass to an inspirational woman. There are times, however, that call for a cocktail with certain utility, and that's what the recipes in this chapter are for. Having a friend or twenty over but still looking to serve great drinks? What could provide a warmer welcome than a brimming bowl of punch? Punch is an easy vehicle for providing perfectly balanced tipples for a crowd without having to miss your own party.

Should that party have a flexible start time and no defined end time, a low-alcohol tipple may be just what you need to work the room from start to finish. These drinks are modern takes on a classic concept, but you can also consider them what beer drinkers call "sessionable," or something you can sip a lot of and still have staying power for a long evening.

Activists

—

You run like a girl, throw like a girl, punch like a girl. We'd love to leave the "like a girl" taunts behind on the playground, but grown-up versions exist in just about every industry in our adult world, including bartending. For years we've been working to prove there is no liquor room that is too strenuous to stock or service ticket that's too lengthy to slay for our sisters in arm garters.

In 2011, after years of bartending "like girls" in some of the most respected cocktail bars in New York City, powerhouse pair Ivy Mix and Lynnette Marrero developed a platform for raising the profile of female bartenders around the globe. Part rivalry, part philanthropy, 100 percent community-building, Speedrack is a women's-only speed bartending competition that raises money for breast cancer research and support charities. Under the scrutiny of four judges and the gaze of hundreds, women duke it out in a bracket

regional competition vying for bragging rights and the opportunity to travel to the finals to be named their country's Miss Speedrack.

Speedrack USA has raised more than $750,000 in eight seasons for breast cancer–related charities. But not all benevolence can be measured numerically. Through the nerves and anxiety, there is a bond of sisterhood that develops among the competitors that extends beyond the competition. Speedrack's network links more than 800 like-minded women who have gone to battle and now look to one another for support and advice. In addition, the Speedrack organization provides mentorship through the Sisterhood Project, which provides an afternoon of programming in each Speedrack market focused on the most important issues to women in the hospitality industry. It's pretty powerful to bartend like a girl!

PEAR-SHAPED PUNCH

YIELD: 25 servings

Glassware: punch bowl

Garnish: edible flowers

INGREDIENTS

» 1 bottle Del Maguey Vida Mezcal

» 4¼ ounces (130 ml) Aperol

» 2¼ ounces (66 ml) Luxardo Maraschino

» 17 ounces (500 ml) Perfect Puree Pear

» 8½ ounces (250 ml) lime juice

» 8½ ounces (250 ml) grapefruit juice

» 4¼ ounces (125 ml) 1:1 simple syrup

By Misty Kalkofen

Del Maguey Single Village Mezcal, Boston, MA

The Pear-Shaped Punch provides an accessible entry into the intriguing and complex category of mezcal. The notes of pear, bright lime, and grapefruit with a touch of bitter orange peel sing with the roasted agave flavors. This recipe makes a healthy portion, so send out the invites!

DIRECTIONS:

Mix all ingredients in punch bowl with ice. Garnish the bowl with edible flowers and serve.

THE BRETON WOMEN OF THE FRENCH RESISTANCE

Activists

—

Wanted: Volunteers for immediate overseas assignment. Knowledge of French or another European language preferred; Willingness and ability to qualify as a parachutist necessary; Likelihood of a dangerous mission guaranteed.

Robert Kehoe was twenty-one years old and bored in Army Signal Corps basic training when that call came over the loudspeaker during lunch. A few short months later, he was parachuting into Brittany under a moonlit sky at a dangerously low height as part of an allied team working with the French resistance.

Better known to us as Kirsten's Great Uncle Bob, Kehoe was part of Jedburgh Team Frederick, one of ninety teams who parachuted into occupied France, Belgium, and the Netherlands to coordinate supplies, guide locals on attacks and sabotage, and assist the advancing Allies using a radio to communicate important encrypted information. It wouldn't have been possible without the brave Breton women who risked their lives to resist.

With the invasion of Normandy, schools were closed, leaving women like Uncle Bob's colleague Simone LaGoeffic and other "schoolteacher saviors" free for subversive activities. Breton production of potatoes and wheat was important to the occupying Germans, so they worked on the farms that were short on labor, allowing them to move about on foot or by bicycle.

"I do not believe the German security services or the Milice ever realized what an extensive network existed," says Uncle Bob. "If so, they would have exerted tighter control." If caught, Simone and her cohorts would have been imprisoned and sent to German labor camps. Nevertheless, they persisted, the strong and courageous "lifeblood of the resistance, furnishing information, passing instructions, and arranging for food and supplies."

Cheers to Simone and her colleagues, an essential part of Jed Team Fred!

JEDBURGH WELCOME PUNCH

YIELD: 25 servings

Glassware: punch bowl

Garnish: ice ring with grapefruit and lime slices frozen inside

INGREDIENTS

» 18 ounces (530 ml) Laird's Apple Brandy

» 6 ounces (175 ml) Yellow Chartreuse

» 12 ounces (350 ml) grapefruit juice

» 12 dashes Angostura bitters

» 3 ounces (90 ml) water

» 1 750-milliliter bottle dry Lambrusco

By Mary Stout

Ruby Wines, Boston, MA

Mary channels some of France's most iconic flavors to create a punch appropriate to welcome Jedburgh Team Frederick on their arrival: exemplary apples from Normandy, the herbaceous Chartreuse of the Carthusian monks of Grenoble, and the ever-prolific wine!

DIRECTIONS:

Mix all ingredients in punch bowl, topping with Lambrusco. Add ice ring and serve.

— DE ASOCIACIÓN MADRES DE PLAZA DE MAYO —
DE ASOCIACIÓN CIVIL ABUELAS DE PLAZA DE MAYO

Activists

—

It is said that there is no love stronger than the eternal love a mother has for her child. A group of Argentine mothers and grandmothers have been proving this since 1976, when a military coup led to a dictatorship that would rule Argentina until 1983. Thousands disappeared in this time, leaving mothers and grandmothers throughout the country in anguish about the whereabouts of their children. Rather than wonder in silence, they took to the streets asking for answers.

In April 1977, fourteen women gathered on a Thursday in the Plaza de Mayo to protest the disappearance of their children. They had met one another at government offices while trying to uncover information about their loved ones. Gatherings of more than three people were prohibited by the dictatorship, so the women paired off into groups of two to march around the Plaza. Las Madres have met weekly for decades wearing their signature white

headwraps, symbolizing diapers, that are embroidered with the names of their missing children. At times, they have been beaten and arrested. Three of the original members have disappeared.

Over time the group has divided into multiple organizations, including the Las Abuelas de Plaza de Mayo. During the dictatorship, women who gave birth while detained would have their children taken away to be handed over to parents approved by the regime. Las Abuelas are dedicated to locating these children so they can be reunited with their grandmothers. By 2016, they had reunited 119 children with their grandmothers.

This is a heartbreaking story, one that on the surface may not seem like a story to raise a convivial toast. But this punch tribute honors the strength that we can find in solidarity, the comfort that can be had with those who have shared a similar experience, and the power in the tenacity to never give up hope.

LOS REUNIDOS

YIELD: 8 servings

Glassware: punch bowl

Garnish: rosemary sprigs and sliced strawberries

INGREDIENTS

» 8 ounces (240 ml) St. George Terroir Gin

» 6 ounces (175 ml) dry vermouth

» 4 ounces (120 ml) lemon juice

» 6 ounces (175 ml) Aperol

» 4 ounces (120 ml) Rosemary Syrup (see below)

» 4 ounces (120 ml) sparkling wine

» 4 ounces (120 ml) soda water

Rosemary Syrup

YIELD: about 1½ cups (350 ml)

» 1 bunch rosemary

» 1½ cups (300 g) granulated sugar

» 1 cup (235 ml) water

By Helen Diaz

Bloodhound, San Francisco, CA

San Francisco–based Helen Diaz uses the aromatic Terroir Gin from local-to-her distillery St. George Spirits for her hopeful toast, Los Reunidos or the Reunited Ones. Terroir Gin features botanicals, evoking memories of northern California such as Douglas fir and California bay laurel.

DIRECTIONS:

Combine ingredients in punch bowl, topping with sparkling wine and soda water. Garnish with rosemary sprigs and sliced strawberries, and serve.

Syrup

Boil water and blanch rosemary by dipping it in boiling water for 45 seconds. Use tongs to cold-plunge rosemary in a bowl of ice water for 1 minute. Strip leaves off the stem and place in blender.

Make simple syrup using 1.5 parts sugar to 1 part water (using same water from stove), stir, and add to blender. Blend for 45 seconds to 1 minute. Strain out leaves using a chinois or cheesecloth.

ASPASIA OF MILETUS

(approx. 470–400 BCE),
First Lady of Athens/Philosopher

—

Aspasia of Miletus defied all the rules of fifth century Athens to become the city's most powerful and influential woman. Born in Miletus (the west coast of modern day Turkey), Aspasia arrived in Athens, where she operated a salon, around 470 BCE. Whether it was a brothel, an institution for intellectualism, or some blend of the two is unclear, but she hosted the most influential men in Athens, including the city's democratic leader, Pericles. She also established a school for girls.

Pericles fell for Aspasia, divorcing his wife and leaving her with his two sons to live with Aspasia in defiance of his own laws; to prevent political alliances by marriage, Pericles had passed a law forbidding

foreign-born from marrying Athenians. He and Aspasia lived as companions and lovers, and they had a son who was his namesake.

The ancient writers had much to say about Aspasia, with each of their writings representing their own bias against her, as Aspasia defied the status quo. Unable to assume the mantle of wife, Aspasia was free to participate in Athenian public life, where she modeled the behavior of a male intellectual. Socrates and his student Plato were both fans; Socrates even joked that Pericles's famous funeral oration was penned by Aspasia.

Sherry: Sipping History

Bartenders and Spaniards love sherry! Sherry is fortified wine that hails from Jerez in southwestern Spain and is made in a variety of styles, ranging from finos, which are pale and bone dry to rich, lush, sweet Pedro Ximinez. It is made in a unique style, using the grapes Palomino, Pedro Ximénez, and Moscatel.

The soil in the Jerez region is a combination of chalk resulting from decomposed marine material, limestone, and clay. It yields a regular still wine that is light, pleasant, and straightforward. The wines are aged in barrels called butts under a thick layer of yeast called flor, which prevents oxidation in the case of the dry fino wines. After six months aging under flor, the winemaker checks the wines and determines, based on the flor's thickness, if the wine will be fino, or a nuttier, oxidized style. Each style is then placed in its own solera, a special system of fractional blending in which old wine is constantly refreshed with new wine. The wine is thus a blend of wines from many different vintages, which in some sherry houses can include wines that are up to 200 years old.

SOUL OF WIT

YIELD: Approximately 8 cocktails

Glassware: 5-ounce (150 ml) punch glasses

INGREDIENTS

» 1 bottle dry sherry
» ¼ cup (60 ml) honey
» 1 orange peel
» 1 cup (160 g) dried cherries
» 1 cinnamon stick
» ½ teaspoon whole cloves
» 1 teaspoon (2 g) allspice
» 1 star anise
» ½ teaspoon coriander

By Jenn Tosatto
Mission Taco Joint, Kansas City, MO

Jenn's Soul of Wit is inspired by Turkish Delight candies, a nod to Aspasia's birthplace. Through the nutty notes of sherry, honey, and cherries, she has created a simple, elegant liquid version of this confection for sipping while waxing philosophical.

DIRECTIONS:

Combine all ingredients in a saucepan and simmer over low heat for 30 to 40 minutes. Serve hot.

- JUNKO -
TABEI

(1939—2016), Athlete
—

Junko Tabei grew up during World War II in a financially strapped family with the stigma of being a "weak child." As is often the case, this characterization was only fitting because Tabei had yet to uncover her strengths. Tabei scaled her first two peaks, Mount Asahi and Mount Chausu, on a school trip at the age of ten, sparking a passion for climbing that propelled her path throughout her life. As climbing and mountaineering were considered sports for men, she frequently encountered negative reactions from those around her. But in 1969, recognizing that there is strength in numbers, Tabei founded the Ladies Climbing Club with the slogan, "Let's go on an overseas expedition by ourselves!"

On May 16, 1975, Tabei became the first woman to reach the summit of Mount Everest, co-leading an expedition of fifteen women and six Sherpa men. This feat was the just the start for this amazing woman, who reached the summits of the highest peaks in seventy nations over her lifetime, saying, "Even if it is hard, you can reach Japan's highest peak if you climb step by step." Throughout her climbing adventures, Tabei noticed damage being done due to the trash and human waste left behind by mountaineers. In response, at the age of sixty-one she enrolled in postgraduate work at Kyushu University focusing on environmentalism.

Junko Tabei was diagnosed with cancer in 2012. For four years, this once "weak child" turned force of nature continued to climb even as she endured rigorous treatments for her disease. Junko Tabei passed away in 2016, leaving a legacy of success through measured persistence.

MORNING DROPLETS OF DEW ON FROZEN GRAPES

YIELD: 1 cocktail

Glassware: Old Fashioned glass

INGREDIENTS

» 1½ ounces (45 ml) Tozai Living Jewel junmai sake

» ¾ ounce (22 ml) Woody Creek gin

» ¾ ounce (22 ml) Carpano Bianco vermouth

» ½ ounce (15 ml) Dolin dry vermouth

» ½ ounce (15 ml) yuzu juice

» 5 or 6 frozen green grapes

By Jessica Lischka

Jimmy's An American Restaurant & Bar, Aspen, CO

Creator Jessica Lischka used a palette of Japanese ingredients to create this refresher, substituting frozen grapes for ice cubes, reminiscent of the frozen summits Junko scaled, her victory over which was sweet.

DIRECTIONS:

Combine all ingredients. Gently muddle grapes to break up while in liquid ingredients. Do not add ice; shake to chill with frozen grapes. Double strain over a BFIC (Big Fucking Ice Cube).

(1907—1977), Photographer

—

From fashion It Girl to World War II photographer, Lee Miller's fascinating life was marked by extremes of staggering beauty and unspeakable atrocity. She got her first big break at nineteen when she narrowly missed being hit by a cabbie in New York and literally fell into the arms of publishing magnate Conde Nast. Within a few months, the captivating Miller was a *Vogue* cover girl, hobnobbing with Roaring 20s glitterati like Josephine Baker and suitor Charlie Chaplin.

A tenacious Miller wanted to be more than a beautiful subject; she moved to Paris to pursue Man Ray as a teacher. She confronted him in a bar and refused to take no for an answer. They lived together as lovers and collaborators for three years. Miller abandoned her career in 1934 to marry wealthy Egyptian Aziz Eloi Bey, shuttering her successful New York studio and relocating to Cairo. Her time as a kept woman was short-lived: Miller returned to Paris in 1937, where she became inseparable from English surrealist Roland Penrose.

At the advent of World War II, the couple returned to Penrose's London home, where Miller was anxious to head to the front lines. As a war correspondent, she captured powerful and horrific images of the Holocaust, which were published in *Vogue*. Miller and *Life* magazine photographer David E. Scherman were the first to enter Hitler's apartments, where he photographed her naked in Hitler's bathtub, with her boots, dirty from trudging through liberated concentration camps, wiped defiantly on the white bathmat.

After the war, Lee, who was also a sexual assault survivor, suffered dearly from PTSD and descended into alcoholism, an all too common side effect of the disorder. She and Penrose moved to the English countryside, where their farm became an artistic mecca for Man Ray, Picasso, and other artists. She found solace in the kitchen, making "surrealist gourmet" meals such as Elizabethan feasts and obscurely decorated cakes. Lee lost her battle with cancer in 1977.

After her death, Lee's son Antony Penrose discovered tens of thousands of images in the attic, negatives she had claimed were destroyed during the war. He has made reviving her story his life's work.

> I'm no good with my hands, though I am good with a screwdriver—taking a camera apart. But sewing on a button? I could scream.

— LEE MILLER

MY NAME IS NOBODY

YIELD: 1 cocktail

Glassware: Old Fashioned glass

Garnish: swath of lemon

INGREDIENTS

» 1 ounce (30 ml) Ancho Reyes

» ¾ ounce (22 ml) sweet vermouth

» ¾ ounce (22 ml) Aperol

» 1 teaspoon (5 ml) Fernet-Branca

By Beckaly Franks

The Pontiac, Hong Kong

"For me there is pure poetry in the idea that Lee Miller, like many photographers, was a 'nameless' storyteller," says creator Beckaly Franks. "Miller is an iconic female figure, so it goes without saying that her name is legend. However, the anonymity of being behind the lens afforded her travel, immersion in global tragedy, the progression of art and a chance to rescue time. The narrative of nobody."

DIRECTIONS:

In a mixing glass, combine ingredients with ice and stir. Strain into an Old Fashioned glass over fresh ice. Garnish with a lemon swath and serve.

(c. 240—c. 274), Warrior Queen

—

The Crisis of the Third Century was a tough time for the Roman Empire, and an excellent time for Queen Zenobia to become Queen of the East.

Septimia Zenobia was born around 240 CE in Palmyra, Syria (then part of the Roman Empire), an important trade center on the silk road. In 258, the very beautiful Zenobia, who claimed to descend from Cleopatra, married the Roman governor of Syria, Lucius Septimus Odaenthus, but she was no trophy wife. The couple enjoyed hunting wild game, which Zenobia did on horseback, clad in a cape made from a jaguar she had killed herself.

Her husband and the two sons from his first marriage were assassinated by his nephew in 266. Some say Zenobia conspired to kill Odaenthus so that her son could become rightful heir, but it seems unlikely given the fate she dealt his nephew: Zenobia had him and his accomplices sacrificed to appease her husband's spirit in the underworld.

Emperors were constantly in flux, and Rome was in chaos. Zenobia took her place as Queen and got swiftly to work. She built temples, palaces, and massive buildings, balanced the economy, built alliances with Arabia, Armenia, and Persia, built trade caravans from India to Rome to Parthia, and even had her image printed on a coin.

Zenobia named herself Queen of the East and invaded Egypt with a tremendous army. She took Alexandria, her "ancestral home," and sent a second army north to capture Ankara. Zenobia's soldiers adored their brave female leader, who accompanied them into battle, often marching miles on foot shouting words of encouragement. She could also out-drink them (yaas, queen!).

Zenobia met her match in Aurelian, an infantry-man who rose to prominence as Roman Emperor. He marched on Palmyra, sieging the city, and without support from her allies in Syria or Egypt, defeat was imminent. Zenobia attempted a midnight escape by camel to seek reinforcements but was captured by Aurelian forces. Palmyra was burned to the ground; the fate of Queen Zenobia remains unknown.

TEA WITH ZENOBIA

YIELD: 1 cocktail

Glassware: collins glass

Garnish: mint, orange peel, and brandied apricot

INGREDIENTS

» 2 ounces (60 ml) Palo Cortado sherry

» 1 ounce (30 ml) Dolin Rouge vermouth

» ¼ ounce (8 ml) apricot brandy

» ¼ ounce (8 ml) Green Chartreuse

» 2 dashes orange bitters

» 3 ounces (90 ml) Moroccan mint tea

By Chantal Tseng

Reading Room of Petworth Citizen, Washington, D.C.

This delightful aperitif mixes sweet wines with herbaceous liqueurs and mint tea for a drink that is sweet, robust, and soothing on the palate.

DIRECTIONS:

Combine ingredients in a collins glass, stir, and add cracked ice. Garnish with mint, orange peel, and brandied apricot.

(1946—2013), Doctor

—

A male professor who takes credit for his female graduate students' work is nothing new, especially in the field of medicine. But in 1978, after Solomon H. Snyder accepted a prestigious Lasker Prize for work that Dr. Candace Pert was instrumental in without naming her or her team, she spoke up.

Pert and her fellow lab assistants discovered one of the most elusive objects in brain research: the receptor in the brain into which opiates, such as morphine, fit. Pert sent a letter to the head of the foundation that presents the Lasker Award, alerting them that she had "played a key role in initiating the research and following it up" and was "angry and upset to be excluded." This made waves in the scientific community, shedding light on the challenges and barriers facing female scientists. Solomon famously responded in a *Washington Post* piece "that's how the game is played." The two later reconciled and Snyder told *The New York Times* that Pert was "one of the most creative, innovative graduate students" he had ever mentored.

Pert went on to build a career researching peptides and their receptors, work that would lead the creative neuroscientist to study the body-mind connection. She discovered the role of emotions, via the neuropeptides of the brain and body, in health, advocating these now popular concepts at a time when they were considered "laughable, radical, even heretical to the Medical Cannon." Pert's book *Molecules of Emotion: The Science Behind Mind-Body Medicine*, became a bestseller. In her later years, Pert founded Rapid Pharmaceuticals, which focused on developing peptide-based drugs to treat inflammation frequently associated as the underlying cause of many medical conditions.

Candace Pert died of cardiac arrest on September 12, 2013 at the age of 67, but she remains a giant among women in this growing field.

> **The body and mind are not separate, and we cannot treat one without the other.**
>
> — CANDACE PERT

BLISS MAKER

YIELD: 1 cocktail

Glassware: highball/collins glass

Garnish: lemon twist and optional edible flower

INGREDIENTS

» 1½ ounces (45 ml) St-Germain

» 1 ounce (30 ml) fino sherry

» 1½ ounces (45 ml) cooled lemon verbena tea (use 2 tbsp [28 g] per 8 oz [240 ml] boiling water)

» 1½ ounces (45 ml) cooled hibiscus tea (use 2 tbsp [28 g] per 8 oz [240 ml] boiling water)

» ¼ ounce (8 ml) Honey Syrup (see below)

Honey Syrup

YIELD: varies

» 1 part local honey

» 1 part boiling water

By Lucinda Weed

Black Penny, New Orleans, LA

Creator Lucinda Weed made this cocktail using ingredients that "stimulate the mind, heart, and respiratory systems: St-Germain is made from fresh elderflowers, historically used for their prophylactic qualities and to treat ailments of the sinuses and respiratory systems; lemon verbena relaxes the mind; hibiscus is used to treat high blood pressure and cholesterol; honey, when made locally, builds immunity to local allergens."

DIRECTIONS:

Preferably starting with everything chilled, combine all ingredients in a glass and top with ice. Give a gentle stir, express a lemon peel, and garnish with peel and optional edible flower.

Syrup

Stir ingredients together until honey is dissolved.

VICTORIA
- EARLE -
MATTHEWS

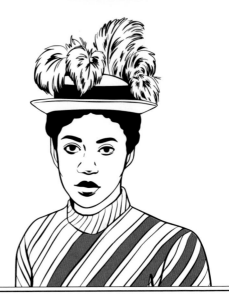

(1861—1907), Social Reformer/Activist
—

As waves of immigrants poured into New York City, Progressive-era settlement houses welcomed them with education, healthcare, and job resources. No such service was available for young black women starting anew in New York, prompting Victoria Earle Matthews to found the White Rose Mission in 1897.

Matthews was born in Georgia, the daughter of an enslaved woman and her white master. Her mother escaped to the north but returned after the Civil War to reclaim her children through court action. In New York, Matthews received some schooling before taking a job as a domestic. Her boss, recognizing Matthews's intelligence, gave her free run of his library.

In 1879, Matthews began writing for the *Brooklyn Eagle* and the national black press. At one time, she was lauded "the ablest writer among our race" by Bishop Alexander Walters of the African Methodist Zion Church. She co-founded the women's Loyal Union, an anti-lynching organization, and was known as a dynamic, gifted speaker and a staunch social justice advocate.

In 1898, Matthews exposed a thriving post-Emancipation system of sex trafficking "employment agencies" that targeted young, poor black women, luring them north with promises of work and delivering them to northern brothels and red-light districts. She described "a perfect network of moral degradation for the unknowingly unfortunate who may happen to fall into its toils."

Matthews founded the White Rose Mission to offer education, job training, and a safe space. Volunteers would meet young women at the docks and train stations and whisk them to the White Rose, which would be their home, school, and community center.

A *New York Age* reporter described Matthews as "a Salvation Army field officer, a College Settlement worker, a missionary, a teacher, a preacher, a Sister of Mercy, all in one, and without being the least conscious of it." Through oration and activism, Matthews sparked a new wave of black social welfare programs.

> **There is no one so black that is not akin to me.**
>
> —VICTORIA EARLE MATTHEWS

WHITE ROSE MISSION

YIELD: 1 cocktail

Glassware: goblet

Garnish: grapefruit peel

INGREDIENTS

» 3 ounces (90 ml) Cocchi Americano Rosa

» 3 ounces (90 ml) club soda

» 4 chunks peach

By Lauren Clark

Haus Alpenz, Somerville, MA

Using a "rosé" variation of a traditional Italian aperitif wine, Lauren Clark pays homage to Victoria Earle Matthews and her White Rose Mission, a refuge for exploited young black women. The peaches are a nod to Matthews' birthplace, Georgia.

DIRECTIONS:

Build in a goblet filled with cracked ice. Garnish with grapefruit peel.

(1631—1703), Philosopher

—

An underlying aspect of this project that we may not have overtly mentioned is that writing is power. By telling the stories of the women in this book, we are giving them a voice and validating their experiences. The assumption when women's stories are absent from a field during a specific time period is that women weren't active in that field at that time. More likely, no one is telling the stories of the women who were participating. Such was the case with the women who were part of "La Querelle des Femmes," a literary battle that took place throughout Europe for more than three centuries. The majority of those participating were men, even though most of the texts that were made public and commented upon throughout the quarrel focused on the inequality of the sexes. Enter Gabrielle Suchon and *A Treatise on Morality and Politics: Freedom, Science and Authority. Where we see that women, despite being deprived of them have a natural aptitude for them. . . .*

Suchon posited that women were "different but equal" and individuals should be considered based upon their abilities, not their gender. Suchon was writing at a time when women had little or no education. Through her thorough understanding of critical social and theological issues, she was able to denounce the subjugation of women and show that it was part of the current political order and not part of the natural order. In 1700, she published a follow-up text, *Celibacy Freely Chosen*, in which she argues that in order to be truly free, women should reject the common belief that they should marry or join a religious order so that they can experience life on their own.

Suchon lived and worked before her time, and she knew it, stating, "Women in my time will never attempt to dispossess men of their might and authority." We raise this toast to women who live before their time and carve the path for their successors.

Vermouth 101

Vermouth is a special category of aperitifs that takes its name from the German word for wormwood, *wermut*. It is essentially an aromatized wine that has been fortified and flavored with herbs, roots, bark, and flowers. Whether red or white in color, white wine is usually used as the base, with color imparted in the vermouth by botanicals.

YIELD: 1 cocktail

Glassware: hurricane glass

Garnish: orange slice and freshly grated cinnamon

INGREDIENTS

» 2 ounces (60 ml) Chenin Blanc

» 2 ounces (60 ml) sweet vermouth such as Lo-Fi Aperitifs or Dolin Rouge

» 1 ounce (30 ml) orange juice

» ½ ounce (15 ml) lemon juice

» ½ ounce (15 ml) cinnamon syrup

By Claire Sprouse

Sunday in Brooklyn, Brooklyn, NY

Creator Claire Sprouse felt a more measured cocktail seemed appropriate for Gabrielle Suchon: "This tipple utilizes a dry, acid-driven Chenin Blanc from her birthplace, Burgundy, while bucking the line of thinking that low-alcohol cocktails have to follow the traditional aperitif format."

DIRECTIONS:

Combine ingredients and whip with crushed ice. Pour contents into glass and pack full with more crushed ice. Garnish with orange slice and freshly grated cinnamon on top. Serve.

THE TOAST CLUB

Welcome to The Toast Club! Toast was started as a Boston area classic cocktail society dedicated to drinking for a cause. We preserve drinks from a bygone era as we educate ourselves about the important and nearly forgotten forebroads who sipped them.

Originally founded in February 2007 as LUPEC Boston (Ladies United for the Preservation of Endangered Cocktails) by Misty Kalkofen and nine fellow cocktail enthusiasts, the organization was the city's first and only female-oriented cocktail society.

In 2017, in an effort to expand our membership and evolve beyond the charter of the founding chapter of LUPEC, we became The Toast Club. In addition to preserving our own personal joie de vivre by guaranteeing members and guests good cocktail parties, The Toast Club strives to enhance and improve the lives of women through fundraising events for women's charities. We partner with local bars and liquor purveyors to offer co-ed classic cocktail parties and special events.

This book was a decade in the making, and dreams like this cannot come to fruition without the help of many.

We offer mountains of thanks to our agent Danielle Chiotti, who saw the potential for this book before we did, and to editor Jonathan Simcosky, who found our blog, which was sleeping, and still envisioned a book. Thank you to project editors Cara Connors and Meredith Quinn, to copy editor Tiffany Hill, and to Christine Eslao, who helps with all our odd research requests. The creative team at Quarry Books has made these pages more beautiful than we could have imagined; thank you creative director Regina Grenier, cover and interior designer Tanya Naylor, and your entire team. Thanks to Adam DeTour Photography for making these cocktails look luscious and to Bijou Karman for honoring the work of the featured women with inspired illustrations. We are grateful to our publicists Lydia Jopp and Debbie Rizzo of DRink PR for spreading the gospel of our humble tome. And, of course, we could not have produced such a unique and timely work without participation from our incredible contributors, all of whom are working bartenders and badass broads, about whom you can read more on the Toast Club website.

· ABOUT THE AUTHORS ·

Misty Kalkofen first stepped behind the bar while studying theology at Harvard Divinity School and soon realized what most excited her about the Bible was the passage in which Jesus turns water into wine. Kalkofen has spent over twenty years honing her craft and has earned a reputation as one of America's foremost authorities on cocktail history and culture. She has been featured in *Bon Appetit, Imbibe, Food & Wine Cocktail* editions, *Wine Enthusiast*, the *Wall Street Journal*, the *Boston Globe, Tasting Panel, Wine & Spirits*, and more. In 2013, she decided to focus attention on her love for all things agave by joining the team of Del Maguey Single Village Mezcal. Always one to find a good reason for a party, Kalkofen founded the Boston chapter of Ladies United for the Preservation of the Endangered Cocktail (LUPEC), thus fulfilling her desire to "cocktail for a cause." Since then, LUPEC has raised more than $40,000 for Boston women's charities by throwing the best parties in town.

Kirsten Amann has more than fifteen years of experience in the beverage industry as a brand ambassador, publicist, bartender, and writer. She is the Boston-based brand ambassador for Intrepid Spirits' Egan's Irish Whiskey and Mad March Hare Poitin and the local brand ambassador for Perfect Puree of Napa Valley. Kitty partners with Jonathan Pogash of The Cocktail Guru as his Marketing and Business Development Guru, representing brands and presenting cocktail events nationwide. Kitty spent four years as Boston's first Brand Ambassador for Fernet-Branca and her past clients include Plymouth, Beefeater, Bols Genever, The Bitter Truth, No. 3 Gin, and more. Kitty works with clients to champion their brands, develop dynamic events, create delicious cocktails, and find a little healthy balance while doing it. She is a founding member of the Boston chapter of LUPEC and the U.S. Bartenders Guild. She writes a monthly cocktail column for the *MA Beverage Business* under the byline "Pink Lady," and her cocktail writing has appeared in *Daily Candy, The Weekly Dig*, and *Chilled Magazine*, among others.